vi

To Bill and Judy Stiteler:

It's not natural for a daughter-in-law

to get such love and support from her in-laws.

Thank you for not disapproving of me.

CONTENTS

INTRODUCTION

I had intended to go to the pet store to purchase a Dusky Conure, but it had been sold. Disappointed, I turned around and found my then-future husband Bill cuddling a small rabbit. I could tell by the look in his eyes he wanted to take it home.

"What good is a rabbit?" I asked. "All they do is sit around in a cage and you take them out and pet them now and then."

"But look how cute it is!" he persisted.

I told him that we should buy a book about rabbits, read it, and then decide whether or not to get one.

A week later, after learning what we could about rabbits, we brought home our first pet, a Dwarf/

Hotot mix we named Latte. He was small, round and white, with black markings around each eye that made him look as though he had on too much make-up.

Latte trained us in the wonders of rabbit ownership, and, much to my surprise, he showed us how much personality and fun a free-roaming rabbit can be. Not long after we brought him home, he sat across the room from us hunched up in a loaf, looking disatisfied. "Oh, he's not happy with us," I pointed out. We laughed and didn't think anything more about it. However, the disapproving looks continued and we soon realized there was no amount of parsley that would ever make him approve of anything we did.

We have owned many rabbits over the years and have learned the hard lesson that it is just impossible to live up to a bunny's standards. But still we strive, finding it a meaningful goal in this life.

Many of the rabbits in this book, including the star, Cinnamon, were adopted from animal shelters.

I was visiting the St. Paul Humane Society with a friend when we met Cinnamon. I saw this beautiful Castor Rex rabbit and put my face up to her cage. She hopped over, frowning as if to say, "I don't approve of you."

I knew she would be perfect for our family.

If, after perusing this book, you think that you are up to the calling of sharing your life with a disapproving rabbit, we encourage you to look up your local House Rabbit Chapter or companion rabbit society. Many find the task of living with the high moral standards of a lagomorph too demanding and relinquish them to shelters. They are in need of good homes.

If after reading this book you find the idea of rabbit ownership terrifying, I congratulate you on your astute assessment and encourage you to donate any amount you can to your local animal shelter.

For more information about rabbit ownership, please visit the House Rabbit Society at www.rabbit.org.

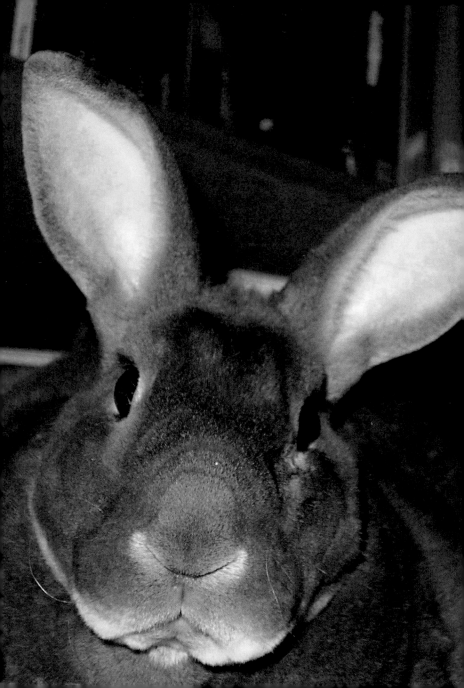

Chapter 1

Disapproval 101

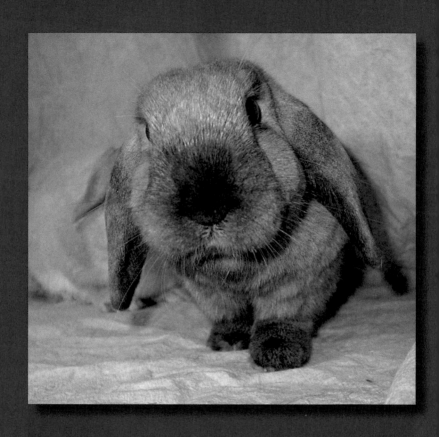

Be careful!
Cute noses can distract you
from deep, deep levels of
disapproval.

Latte prepares to disapprove.

3

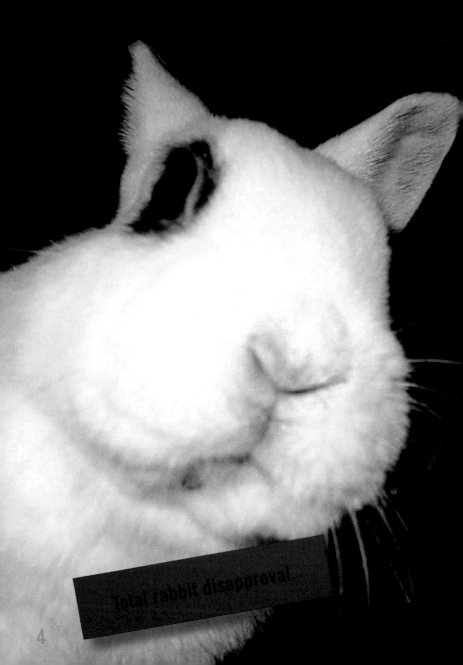

Total rabbit disapproval.

4

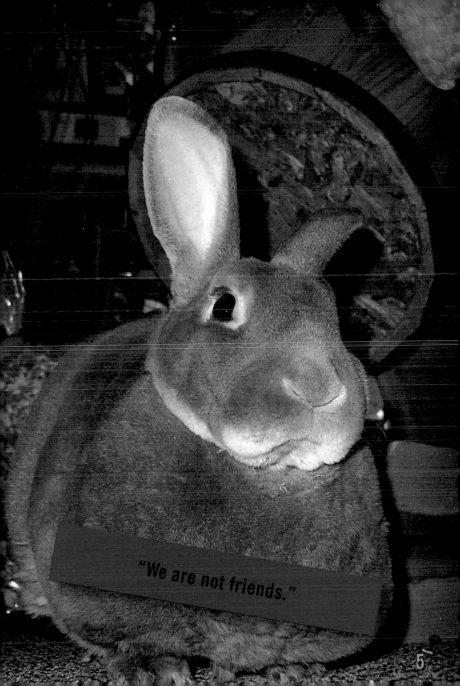

"We are not friends."

5

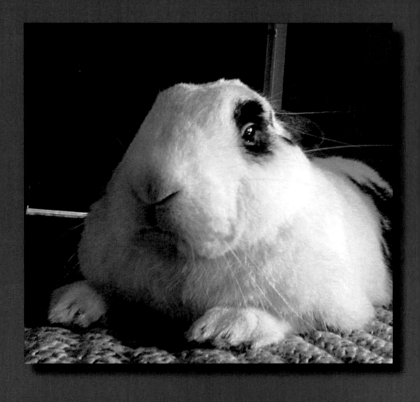

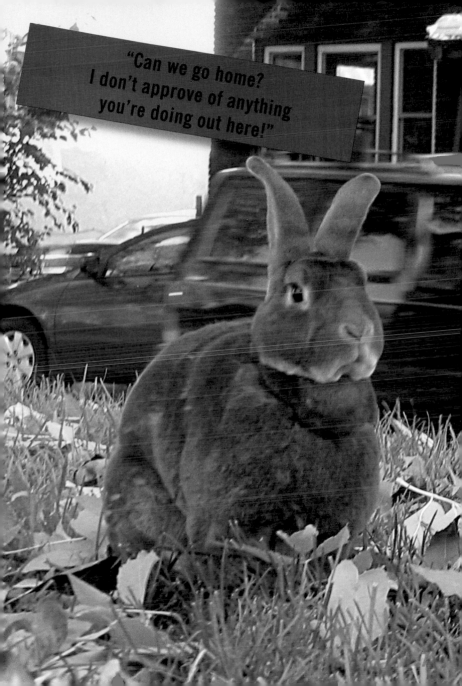

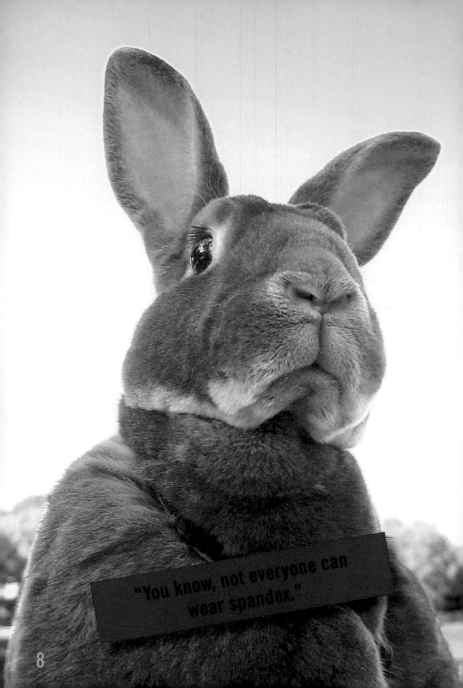

"You know, not everyone can wear spandex."

8

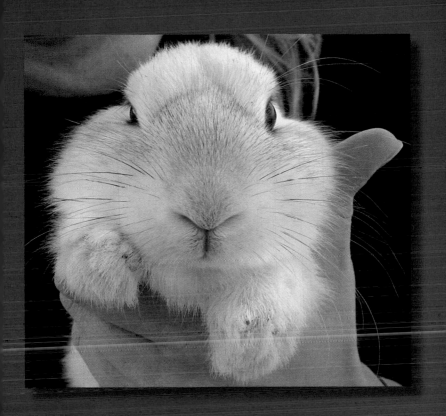

"From up here, you still look ugly."

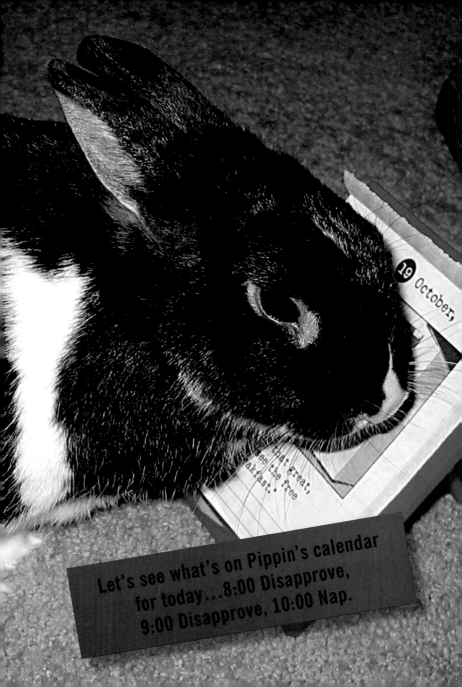

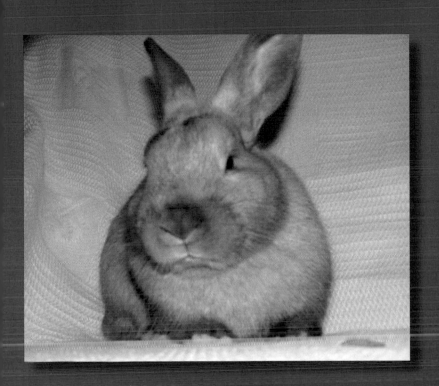

"I'm gonna mess
you up good."

11

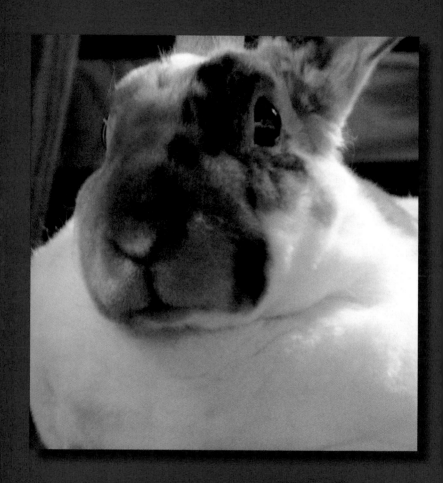

"That boy ain't right."

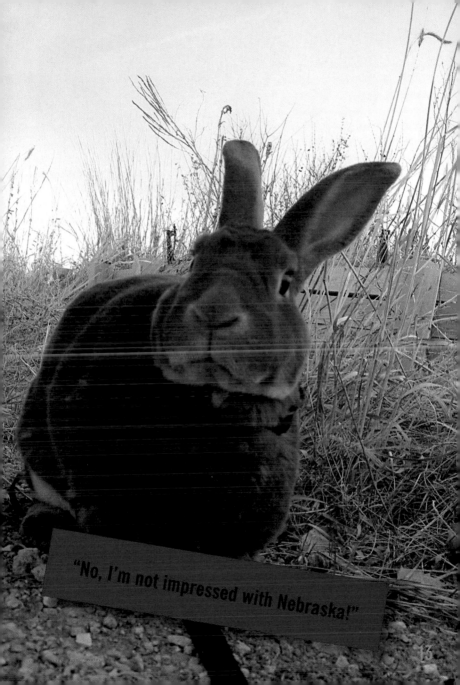

"No, I'm not impressed with Nebraska!"

13

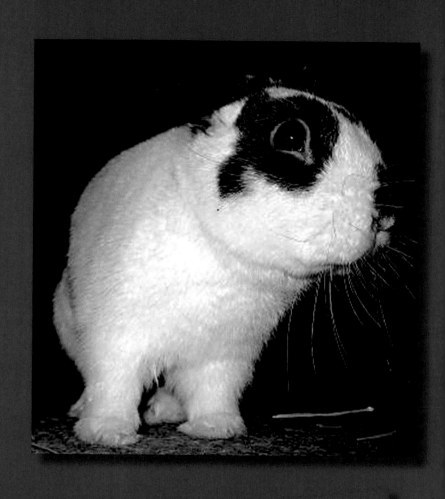

"I dare you, call me a panda one more time..."

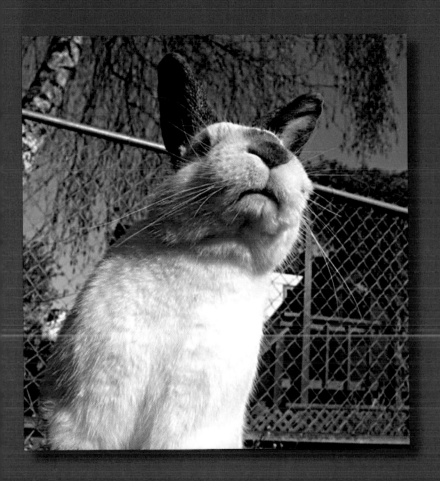

"My disapproval cannot be contained!"

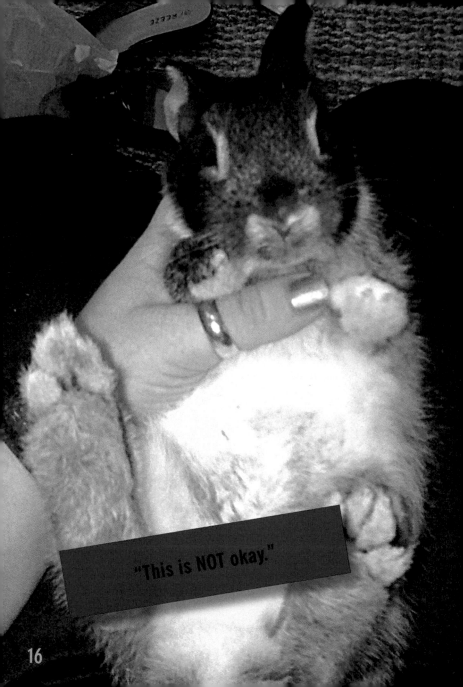

"This is NOT okay."

16

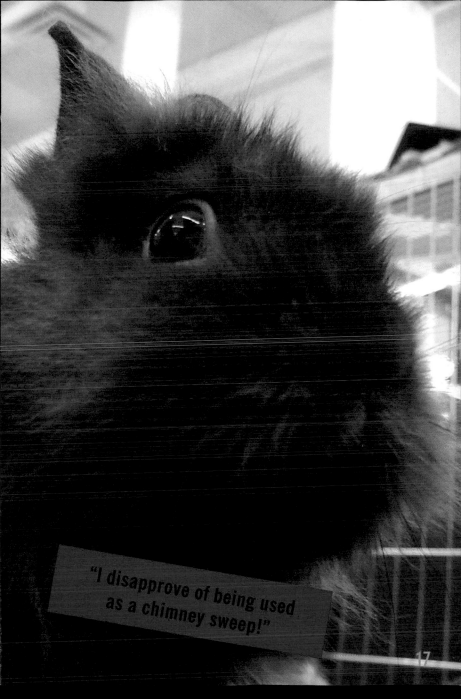

"I disapprove of being used
as a chimney sweep!"

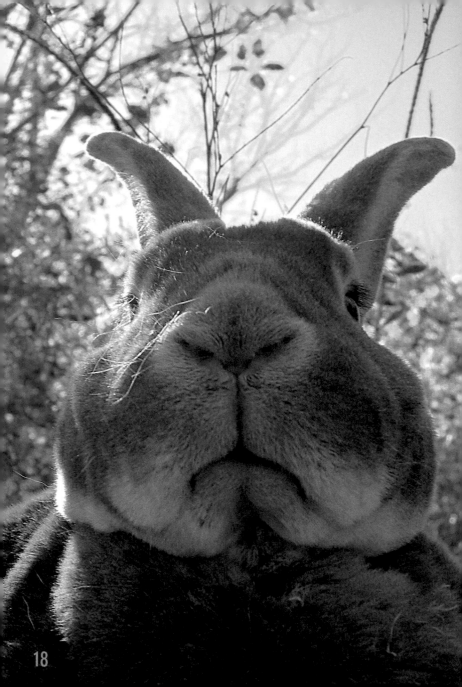

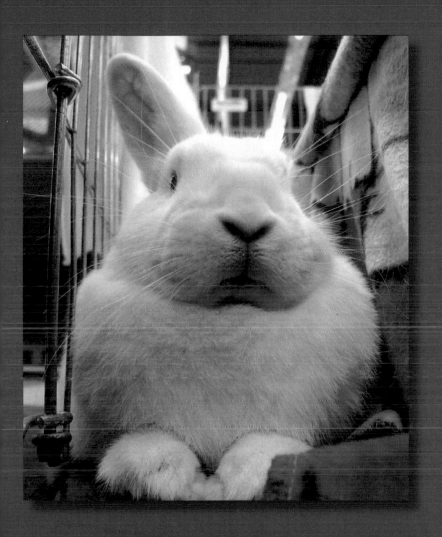

Point blank disapprovals can knock over small children.

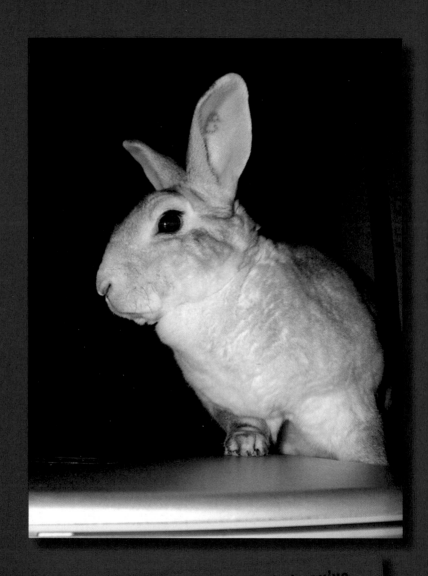

"We need to talk about what you've been doing on the Internet."

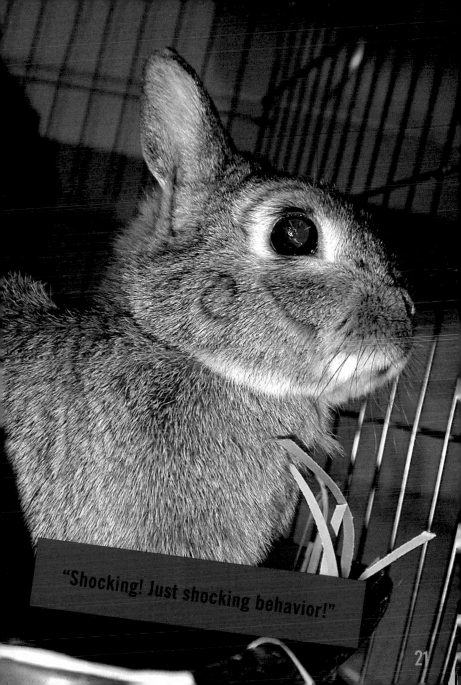

"Shocking! Just shocking behavior!"

21

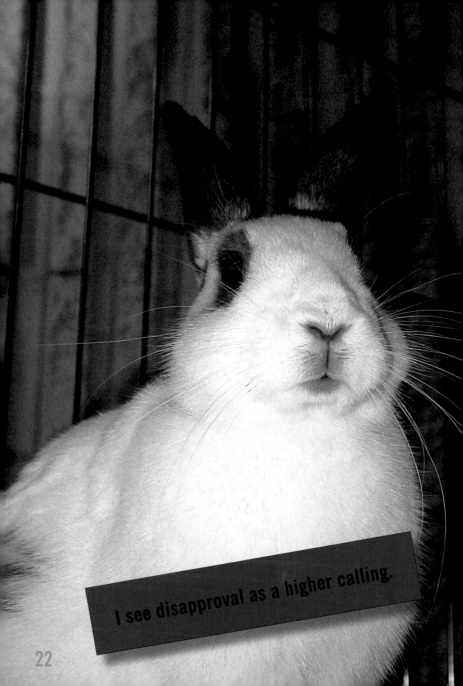

I see disapproval as a higher calling.

22

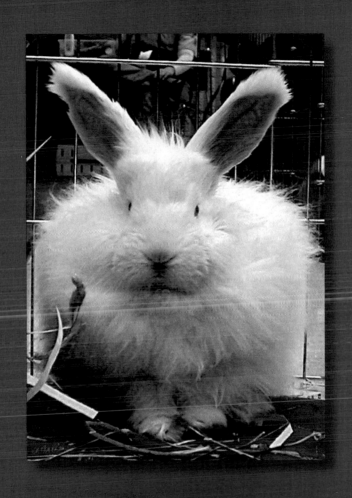

I disapprove of static electricity.

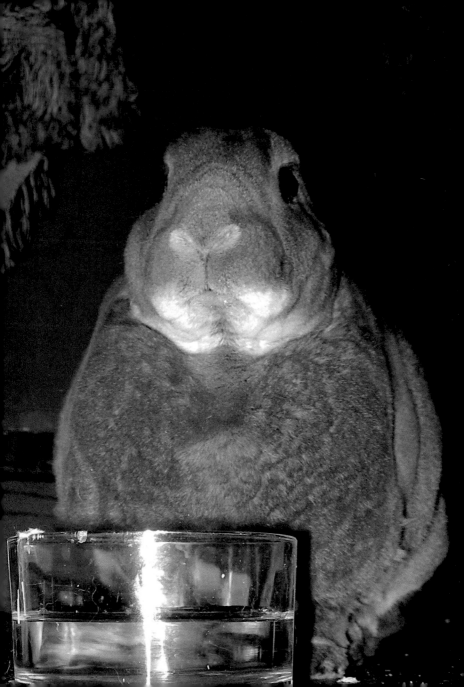

Chapter 2

The Theory of Rabbit Disapproval

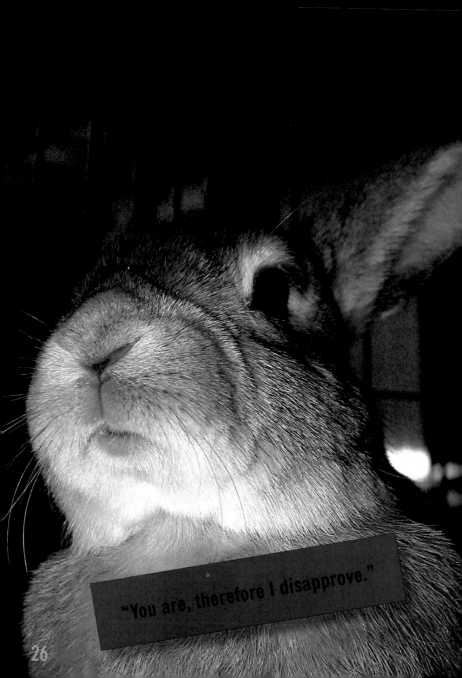

"You are, therefore I disapprove."

26

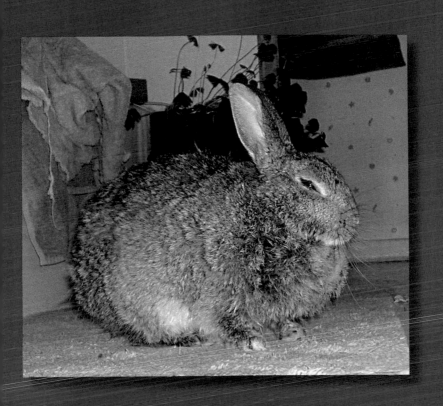

CATHAI'S DISAPPROVAL HAIKU:
Bath time is deep hate,
Deep disapproval, hurtful
Vengeance is to come.

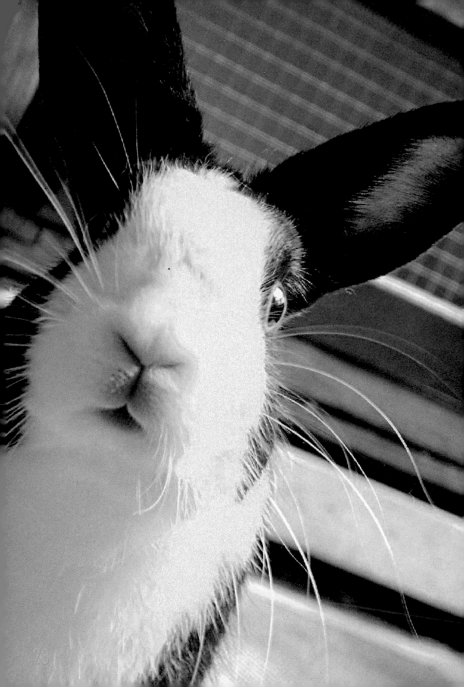

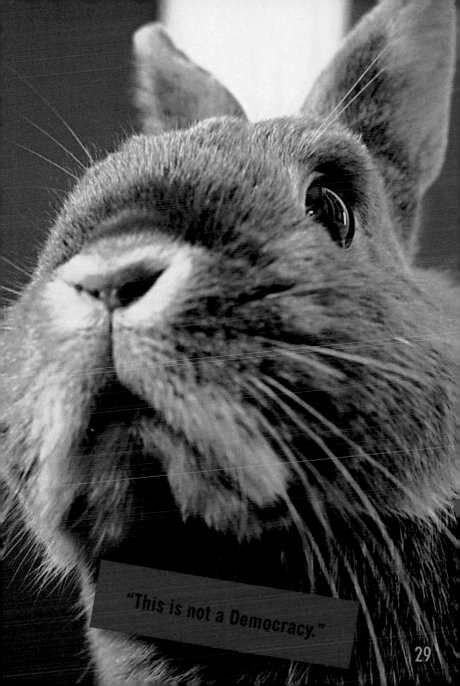

"This is not a Democracy."

29

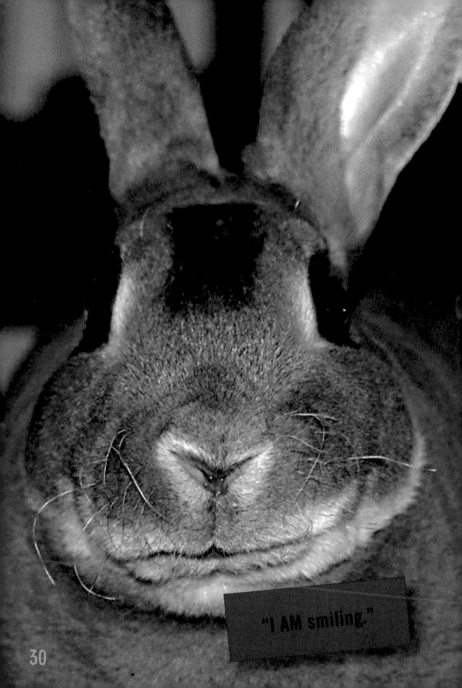

"I AM smiling."

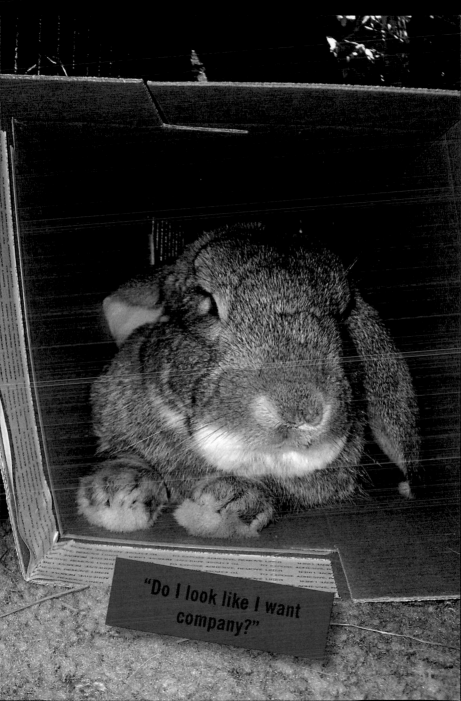
"Do I look like I want company?"

Jack dispenses 100% Organic Free-Range Disapproval.

32

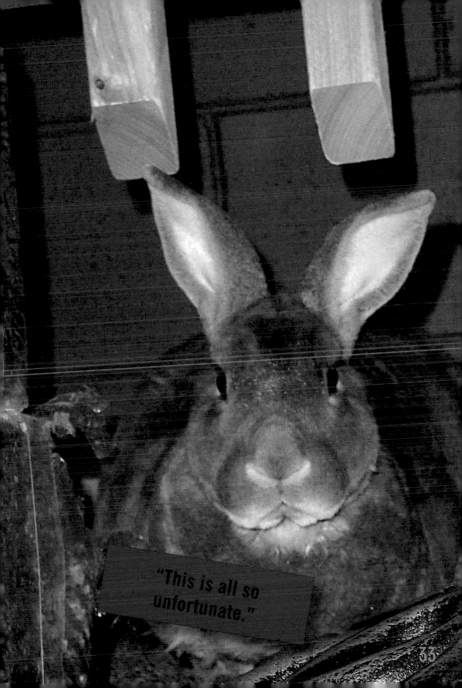

"This is all so unfortunate."

33

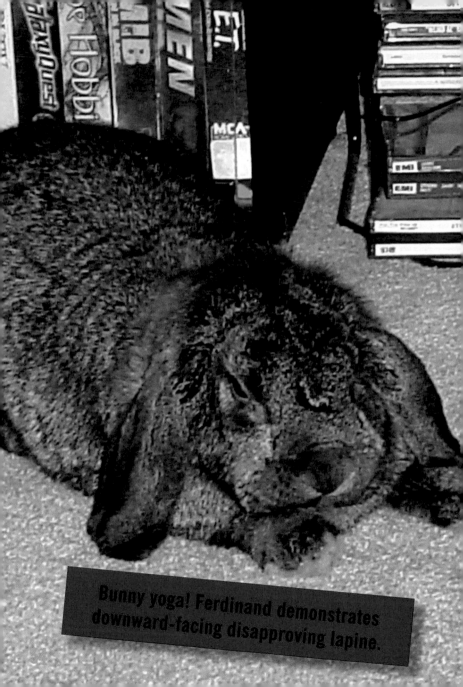

Bunny yoga! Ferdinand demonstrates downward-facing disapproving lapine.

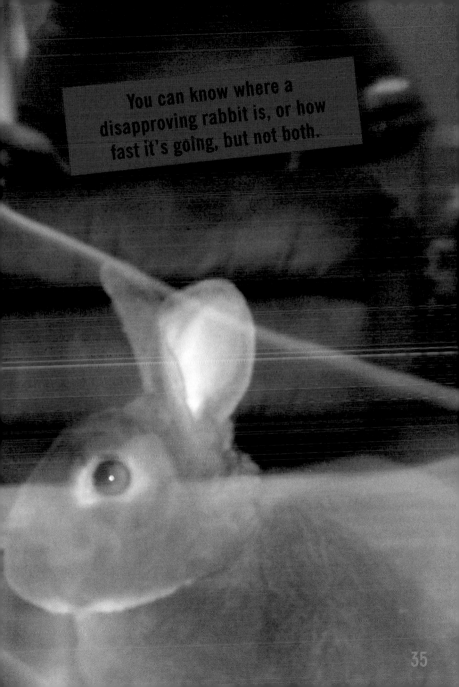

You can know where a disapproving rabbit is, or how fast it's going, but not both.

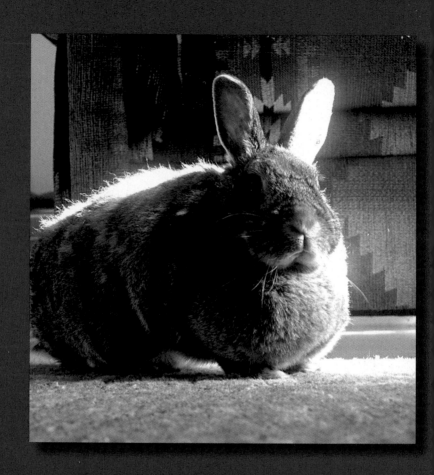

The soft glow from deep,
inner disapproval.

"Watching me doesn't make
it come out any faster."

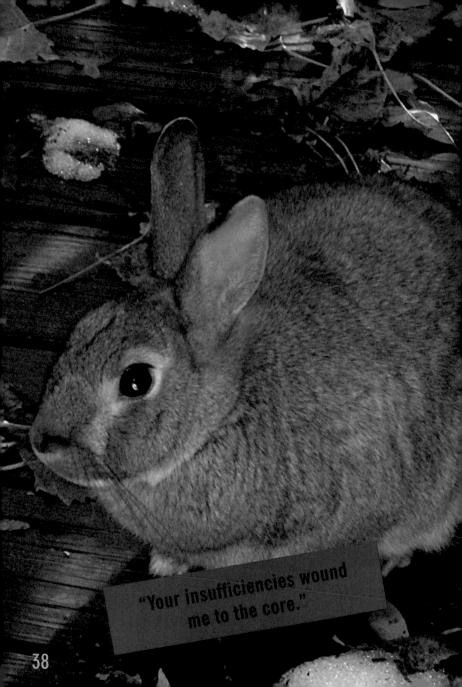

"Your insufficiencies wound
me to the core."

38

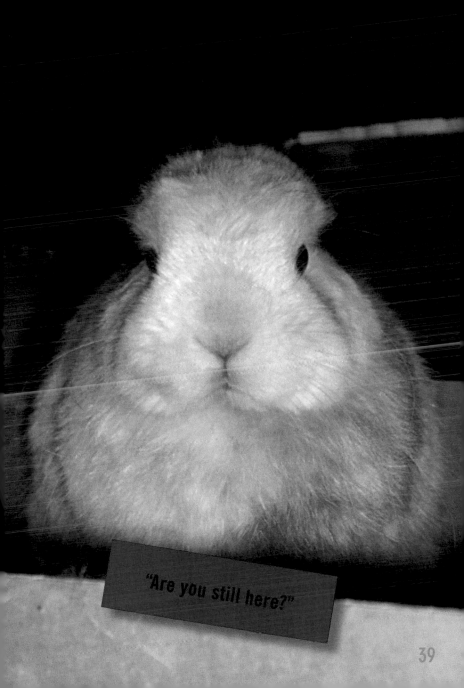

"Are you still here?"

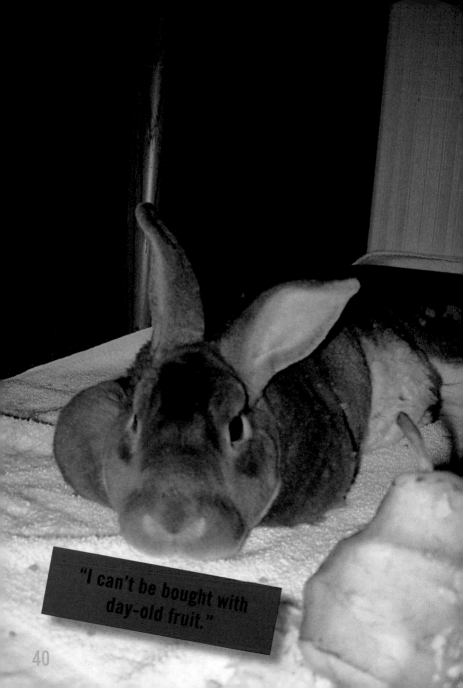

"I can't be bought with day-old fruit."

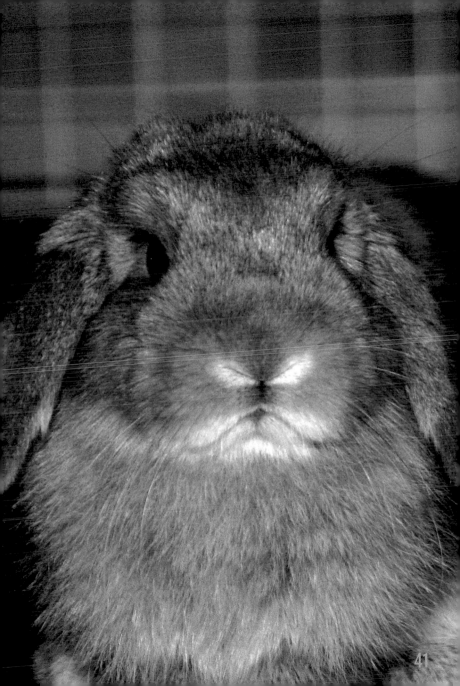

"Well maybe you shouldn't have put your finger there."

42

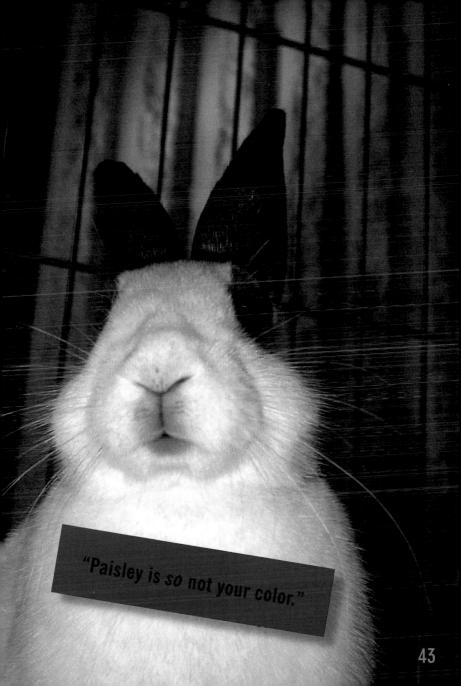

"Paisley is so not your color."

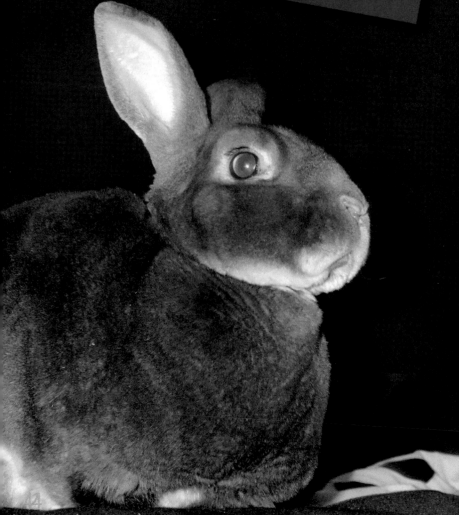
"You are so unacceptable; I don't know why I bother."

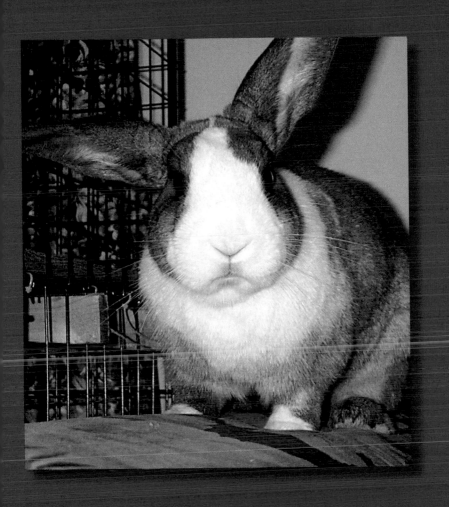

Highly sensitive ears allow a bunny to pinpoint the exact moment you fail to meet its standards.

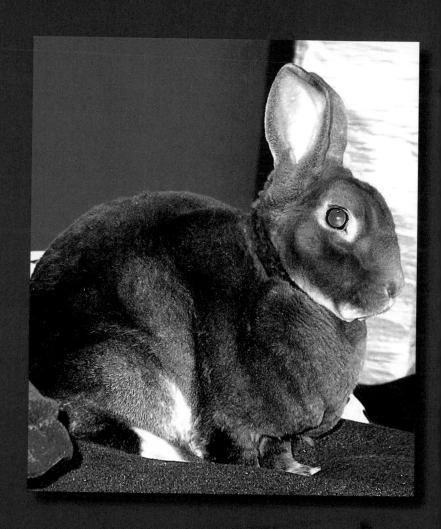

"I am not made of chocolate."

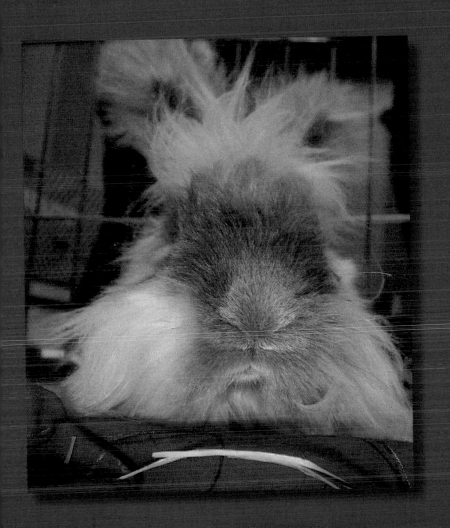

Though blind with fur,
bunny disapproval
transcends mortal senses.

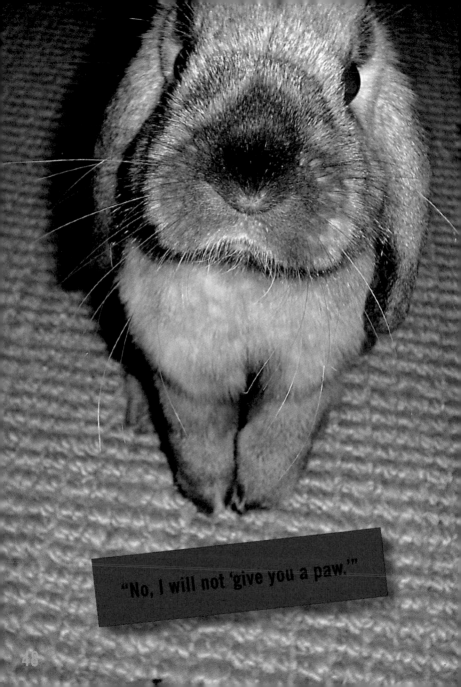

"No, I will not 'give you a paw.'"

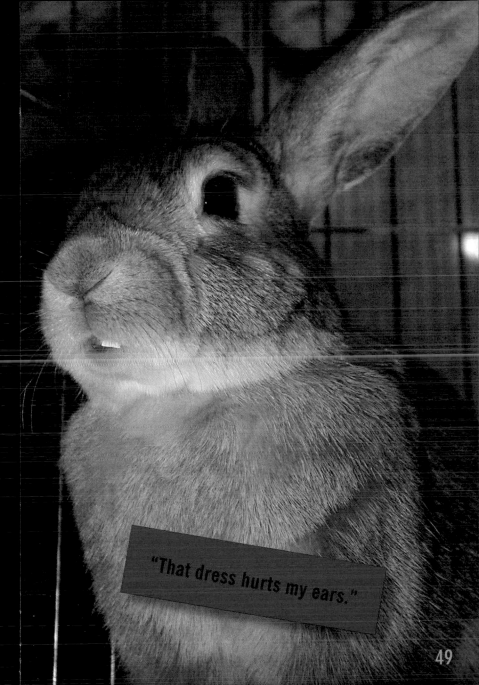

"That dress hurts my ears."

49

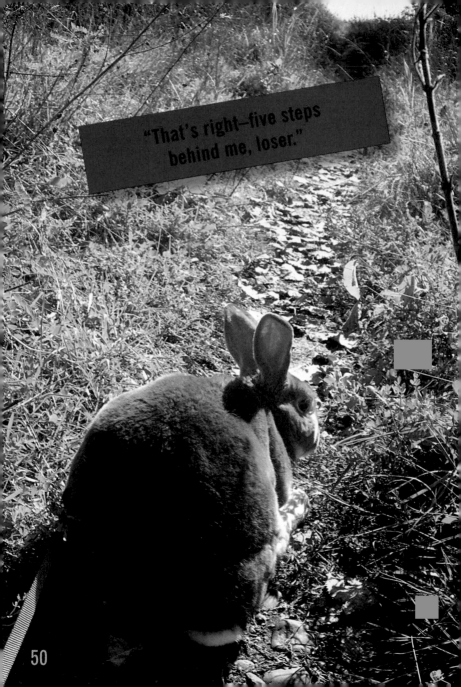

"That's right—five steps behind me, loser."

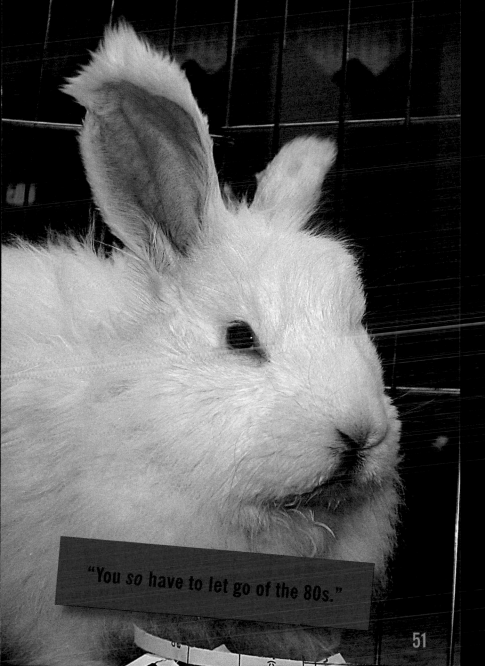

"You *so* have to let go of the 80s."

51

"Ooooh, why did I disapprove
so much?"

The Arc D'isapproval.

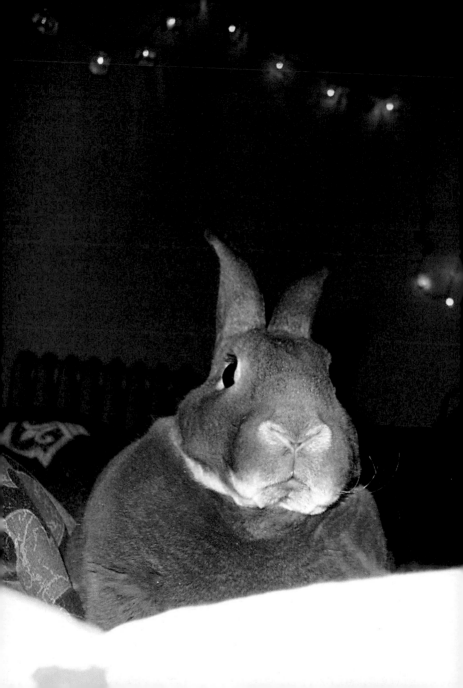

Chapter 3

Rabbits Disapprove of Shabby Chic

Benjamin disapproved of this chair.
His owners wisely got rid of it.
Benjamin then disapproved
of the empty space.

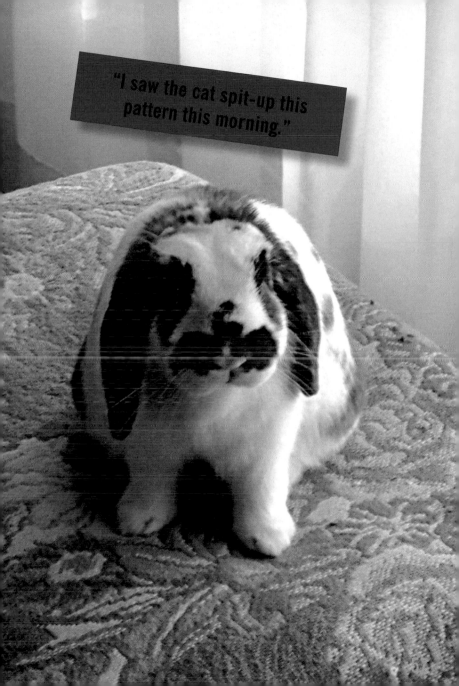

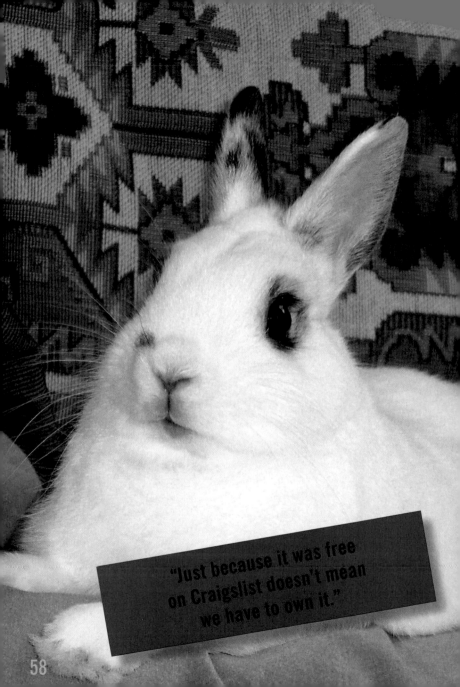

"Just because it was free on Craigslist doesn't mean we have to own it."

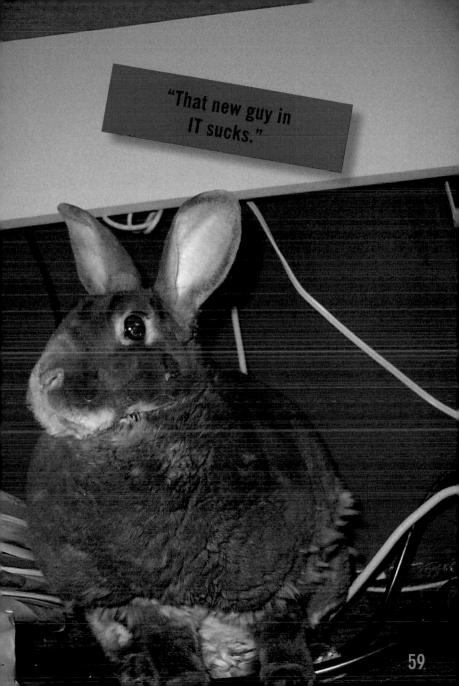

"Do I stare at YOU in the bathroom?"

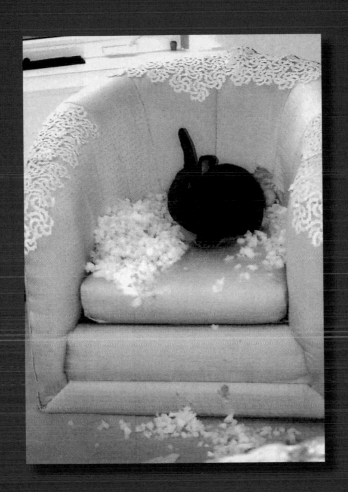

'Nuff said.

"My fee for this week's disapproval: your soul."

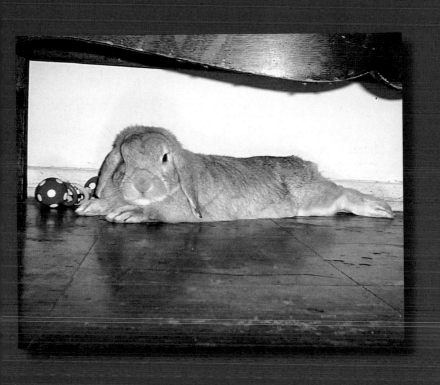

Left untreated, dust bunnies can
grow to clog vacuum cleaners
with their disapproval.

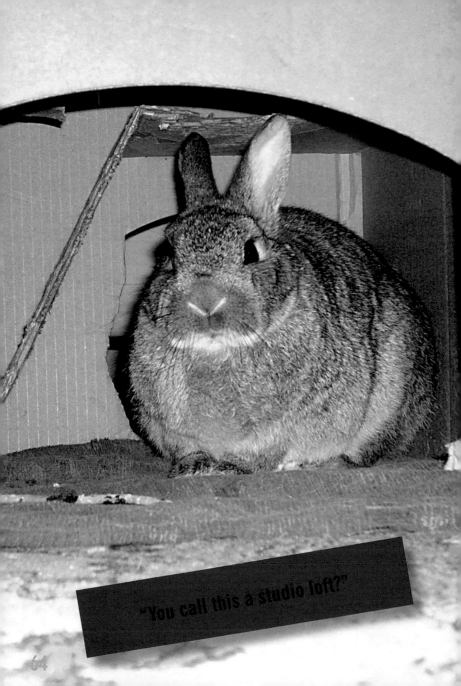

"You call this a studio loft?"

64

"I disapprove of your thread count!"

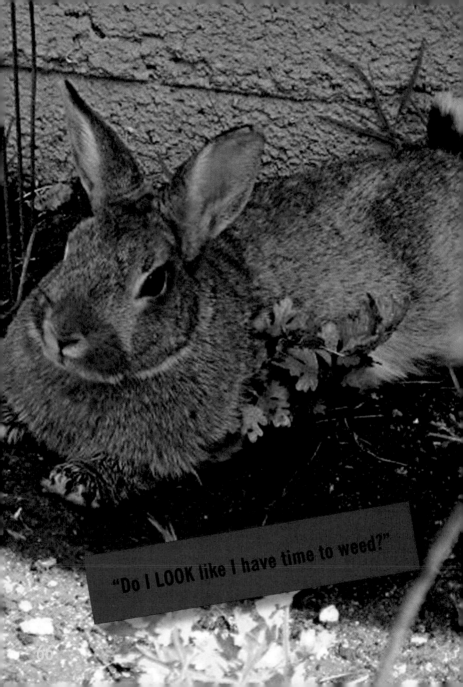

"Do I LOOK like I have time to weed?"

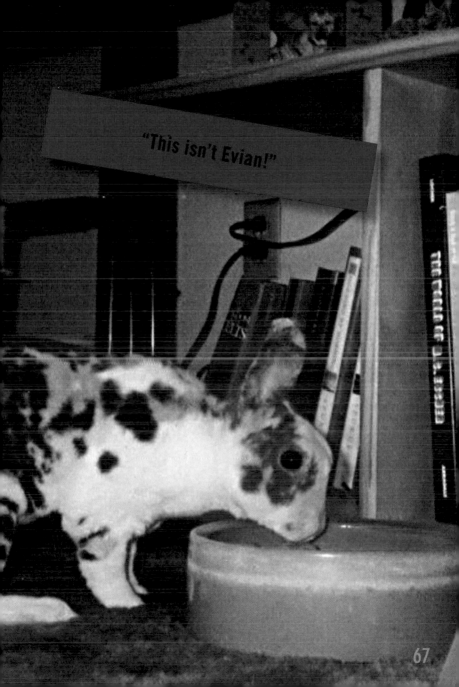

"This isn't Evian!"

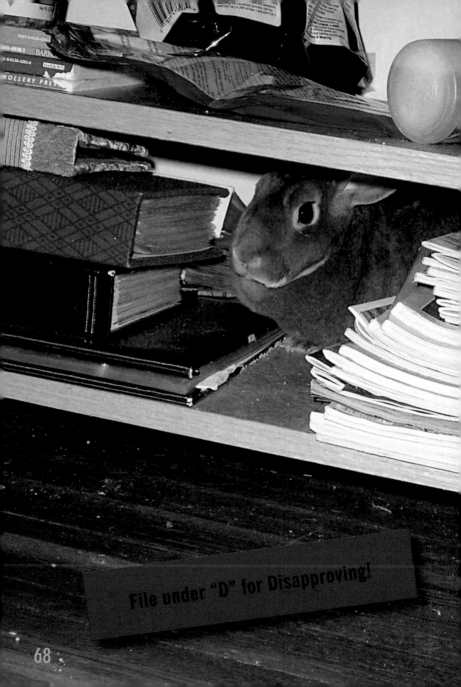

File under "D" for Disapproving!

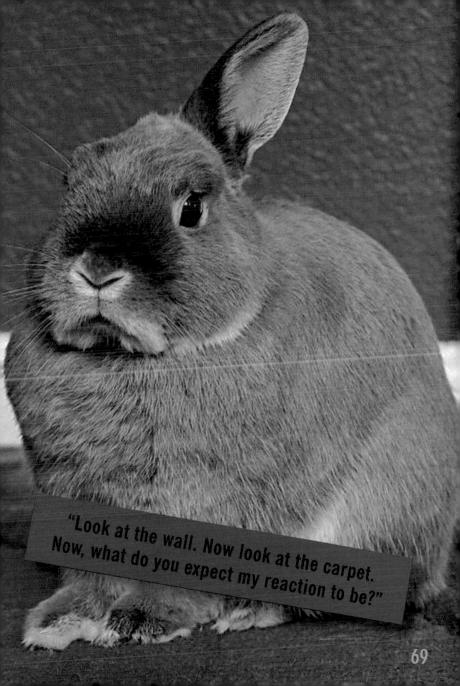

"Look at the wall. Now look at the carpet. Now, what do you expect my reaction to be?"

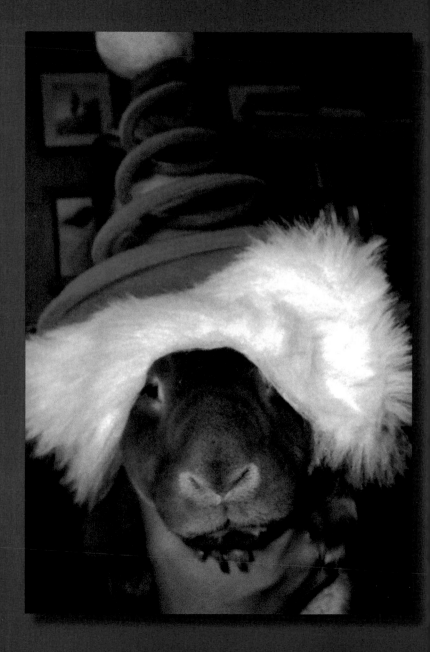

Chapter 4

Lookin' Good
Disapprovin'

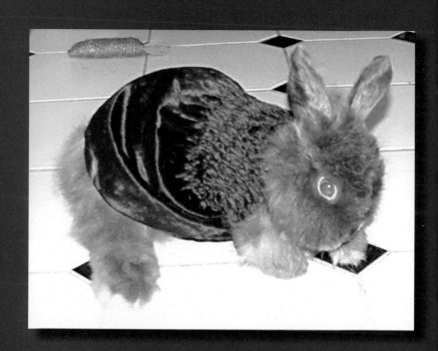

"Repeat after me:
'Never dress a bunny.'"

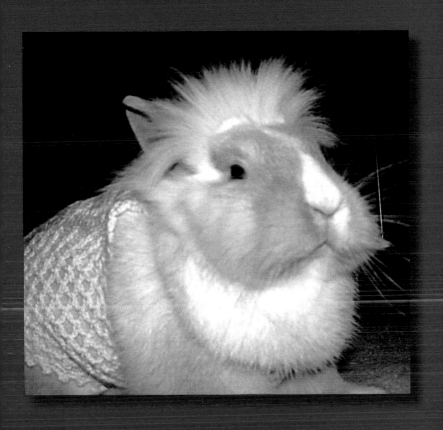

In a situation like this, just back away slowly and pray they can identify you by dental records.

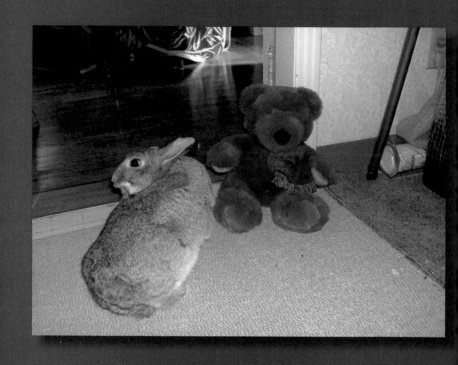

"I can't *believe* you
gave me this dorky bear."

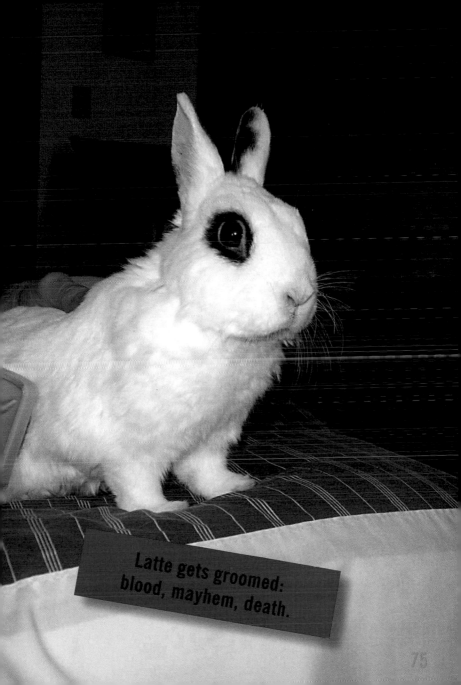

Latte gets groomed:
blood, mayhem, death.

Mort disapproves of split ends!

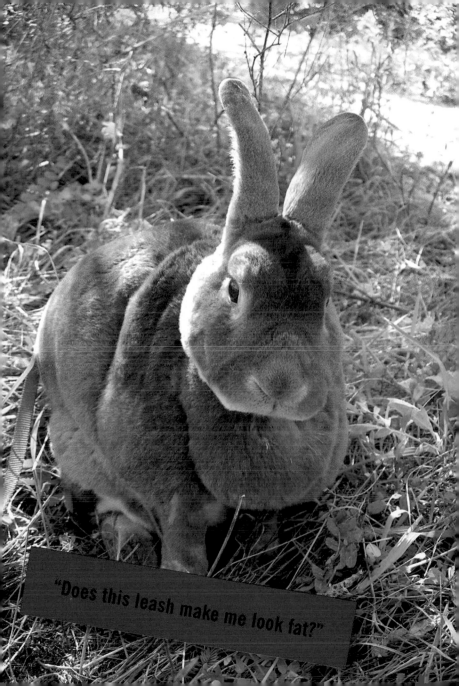

"Does this leash make me look fat?"

"I dare you to come one step closer with that tutu."

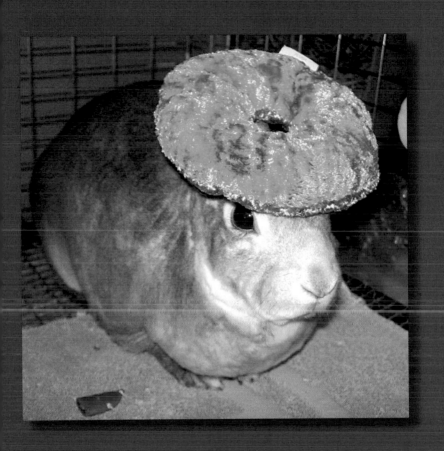

"Where am I supposed to find a purse to go with this?"

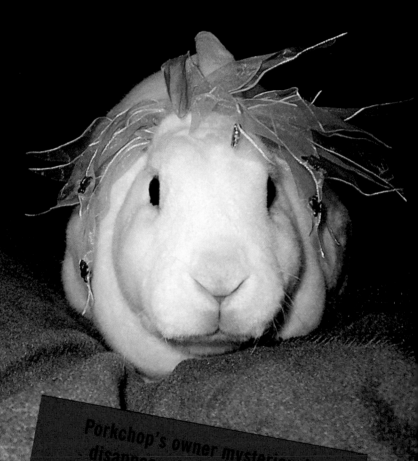

Porkchop's owner mysteriously disappeared two weeks after this photo was taken.

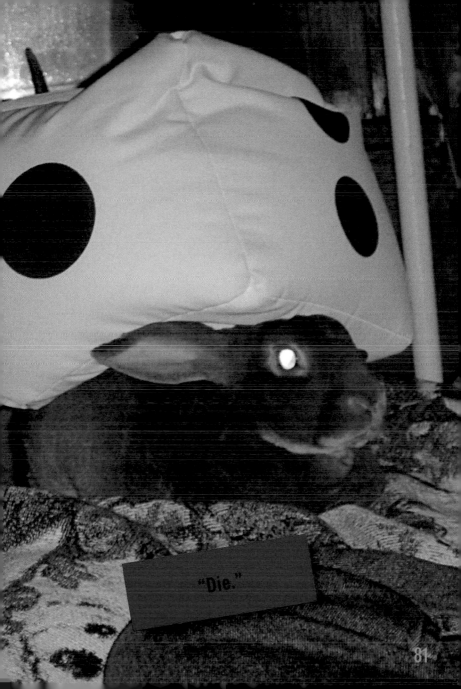

"Die."

Buddy gets a booster shot of pure, liquid disapproval.

83

Harry disapproves of this sweater.
He's clearly an "autumn."

"And lo, Desdemona, the Angel of Disapproval was visited upon them, and the people were confused, and were not quite sure what they had done wrong..."

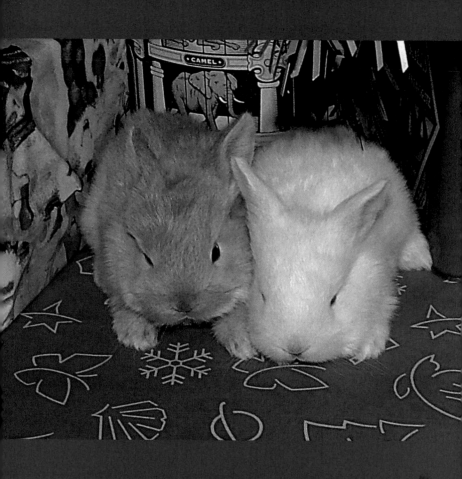

The bunnies were disapproving
under the tree with care…

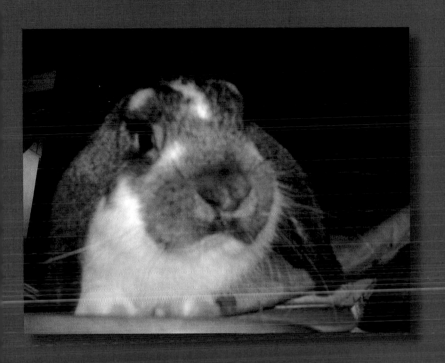

There is no such thing as
a little disapproval.

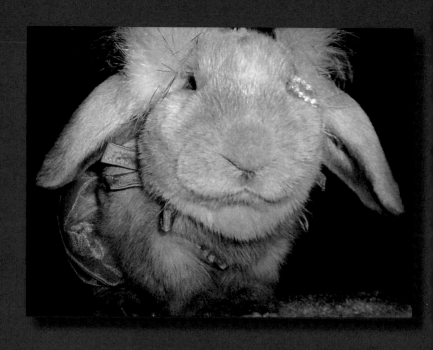

"No jury in the world
would convict me."

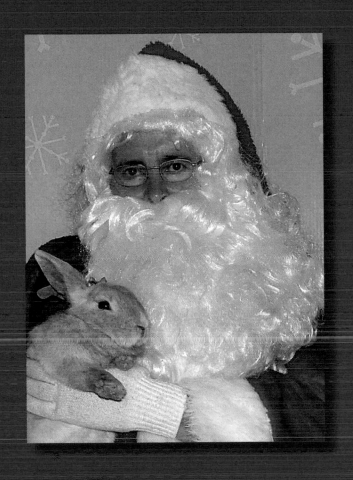

"If you're the real Santa Claus, I'm the Easter Bunny."

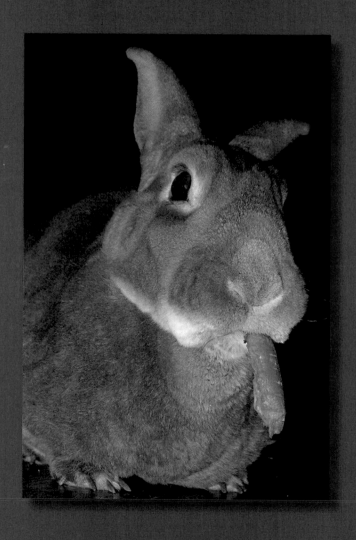

Chapter 5

Rabbits Disapprove of Hasenpfeffer

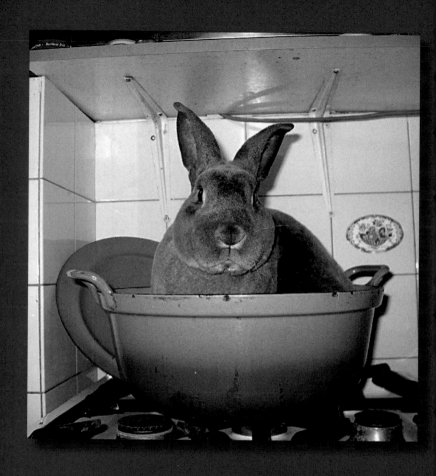

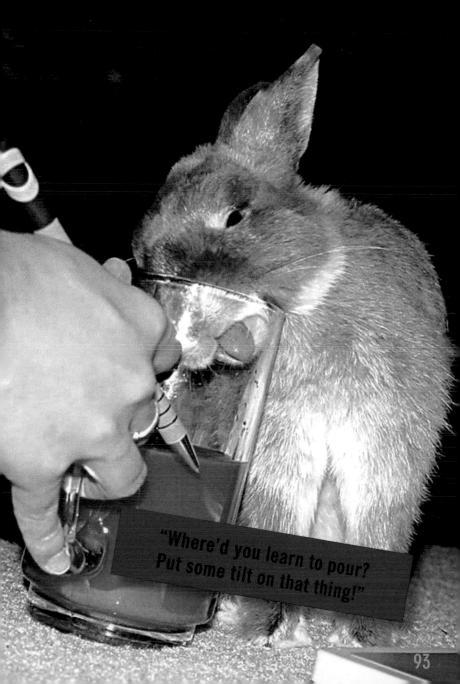

"Where'd you learn to pour?
Put some tilt on that thing!"

93

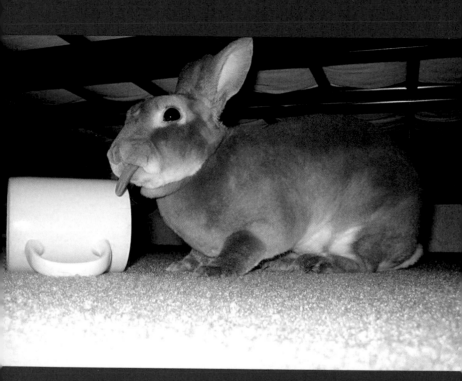

"Who gave me decaf?"

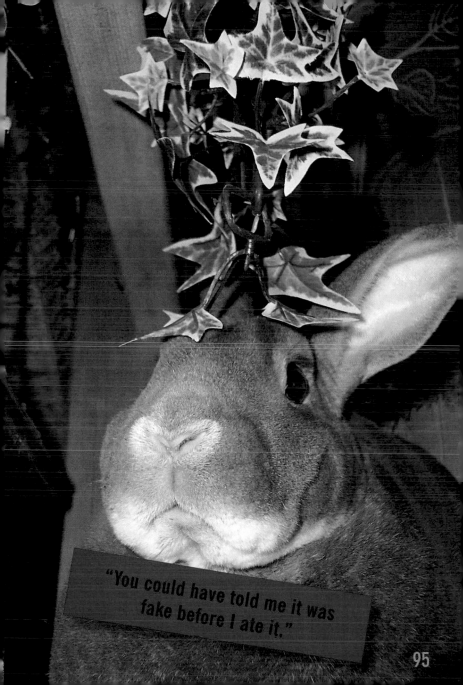

"You could have told me it was fake before I ate it."

95

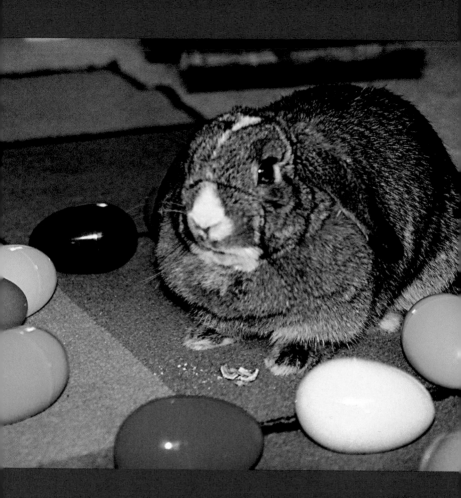

"'Hippity, hoppity,' my butt.
I'm going back to bed."

"Nothing to see here!"

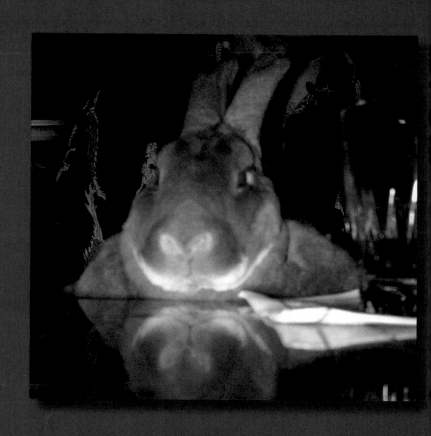

"I disapprove of being cut off! Hic!"

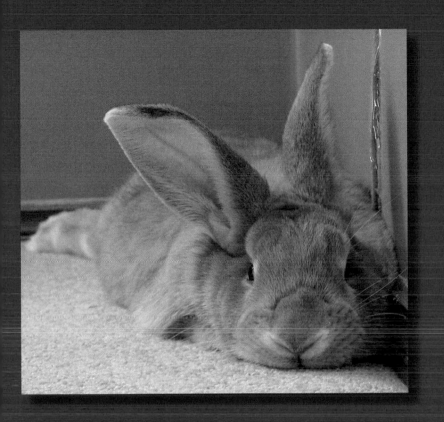

Extra-large ears allow for Flynn to find disapproval within a 50-mile radius.

For maximum security, have your documents shredded, digested, and disapproved.

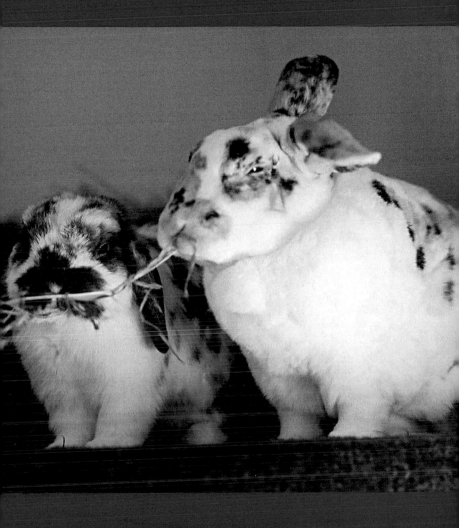

Rabbits who put the *die* in diet.

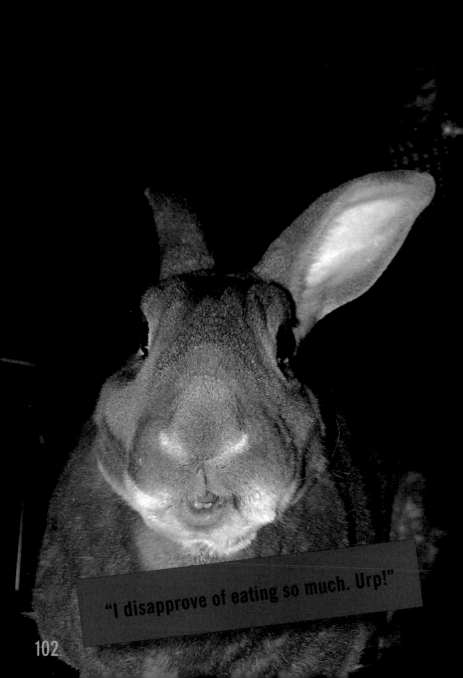

"I disapprove of eating so much. Urp!"

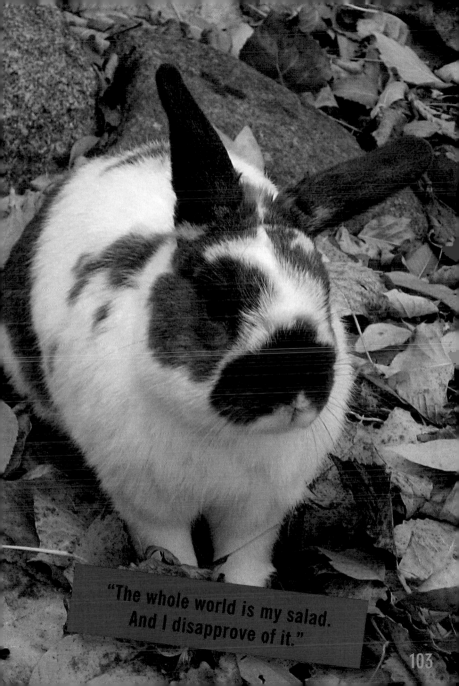

"The whole world is my salad.
And I disapprove of it."

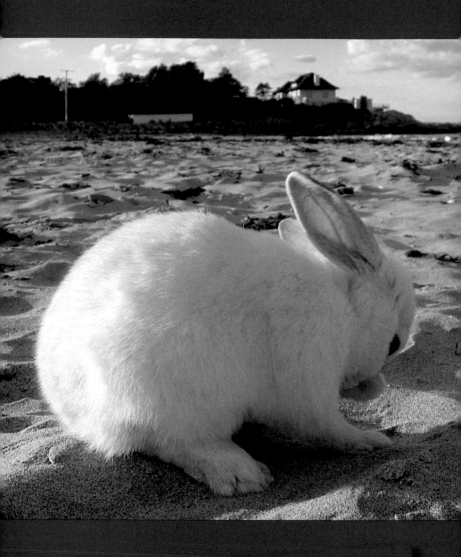

"That Brazilian wax
was a HUGE mistake."

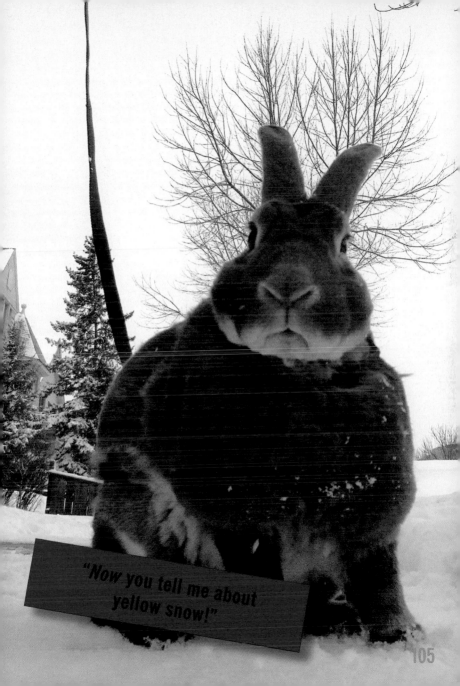

"Now you tell me about yellow snow!"

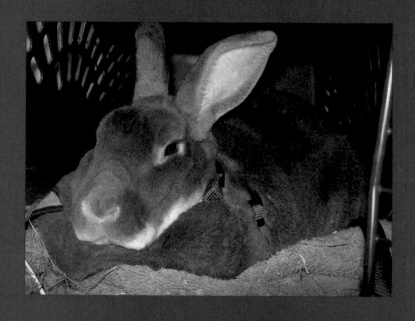

Chapter 6

Rabbits Disapprove of the Daily Grind

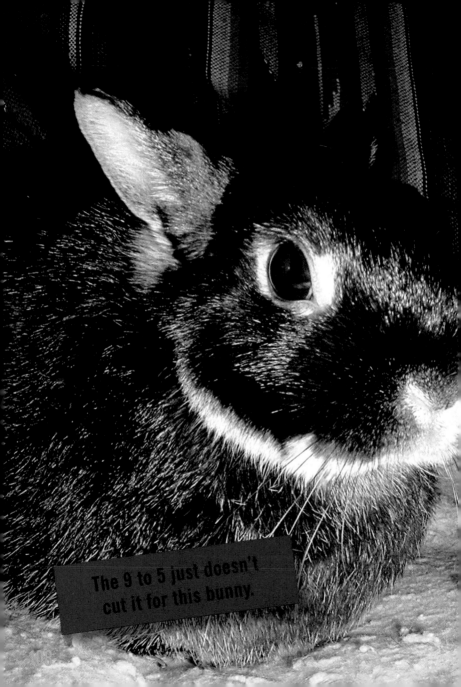

The 9 to 5 just doesn't cut it for this bunny.

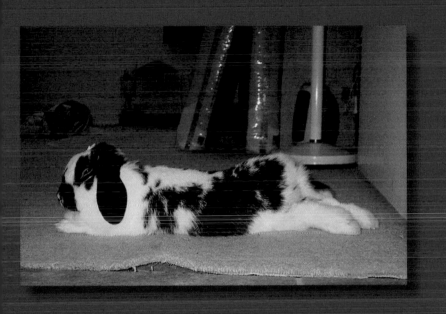

"Trust me, this is hard work."

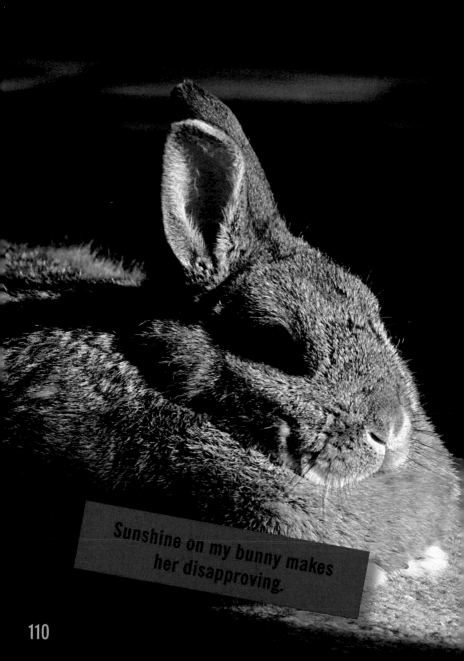

Sunshine on my bunny makes
her disapproving.

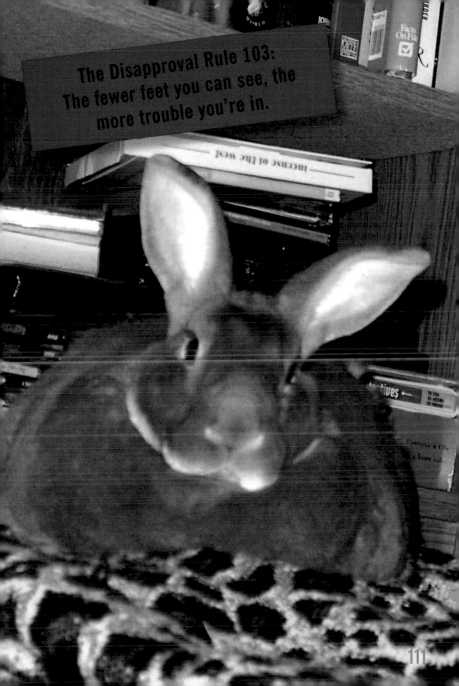

The Disapproval Rule 103:
The fewer feet you can see, the
more trouble you're in.

111

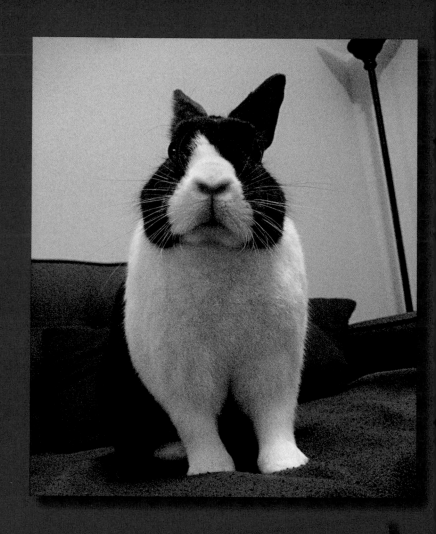

"Early to bed and early to rise
doesn't change my attitude one bit."

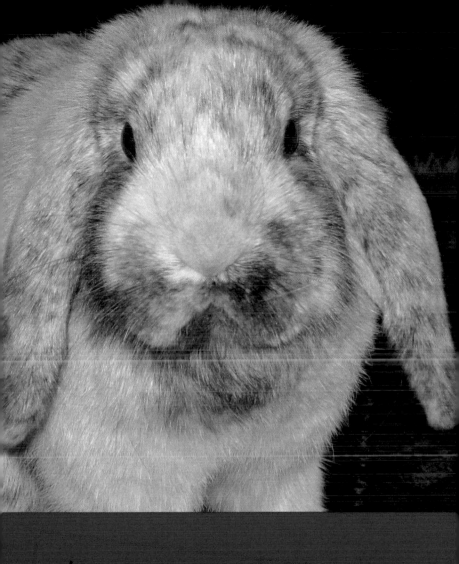
Last photo taken by this photographer.

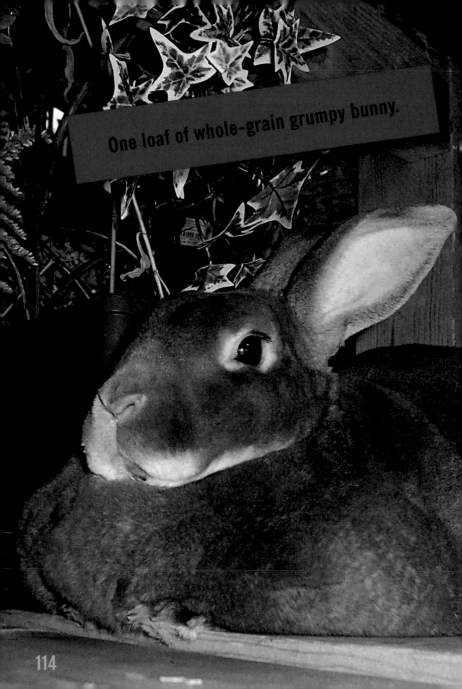

One loaf of whole-grain grumpy bunny.

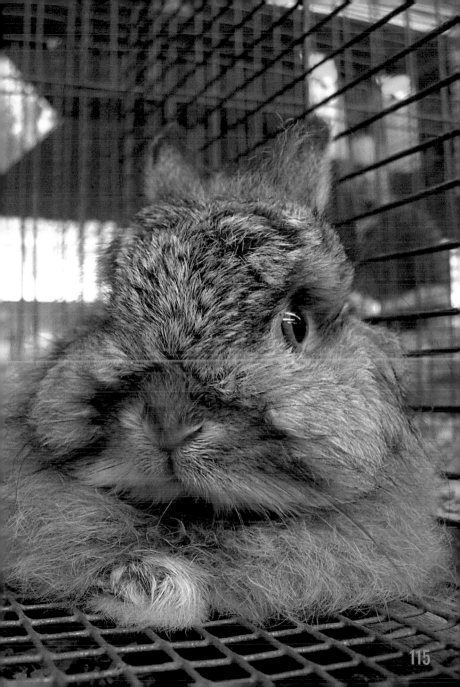

"I've got my eye on you—my evil, glowing eye."

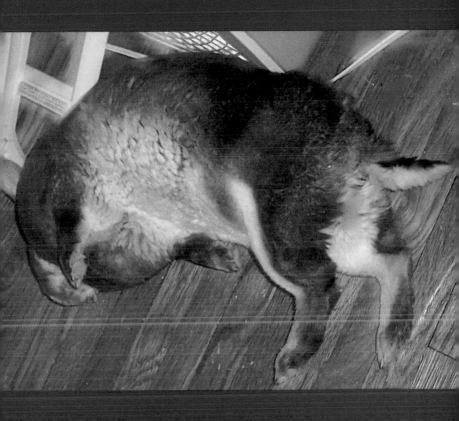

Perhaps one disapproval too many...

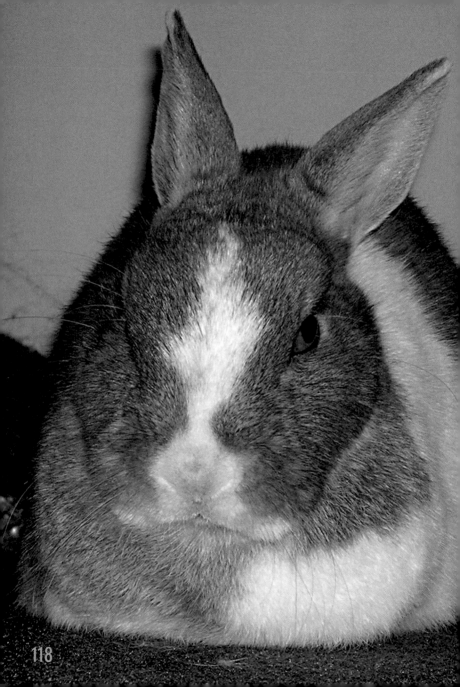

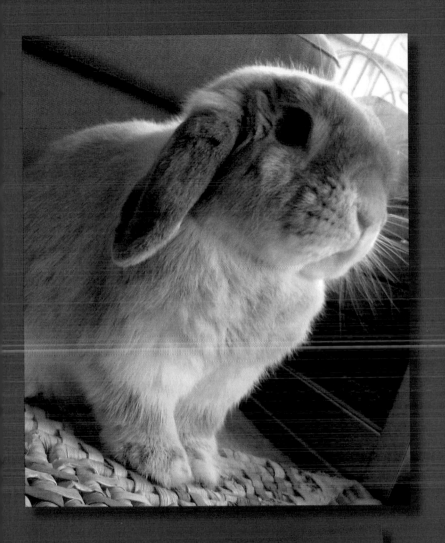

Concentrated disapproval.

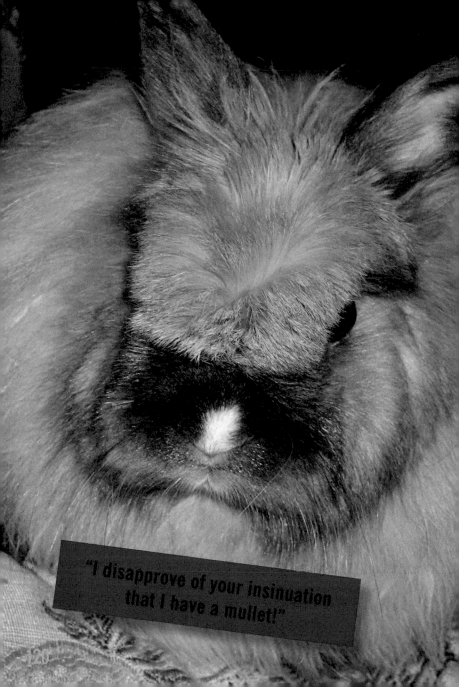
"I disapprove of your insinuation that I have a mullet!"

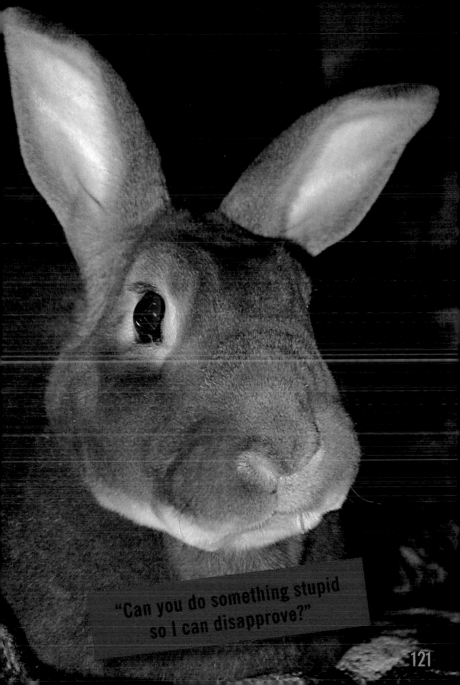

"Can you do something stupid
so I can disapprove?"

Chapter 7

No Known Survivors

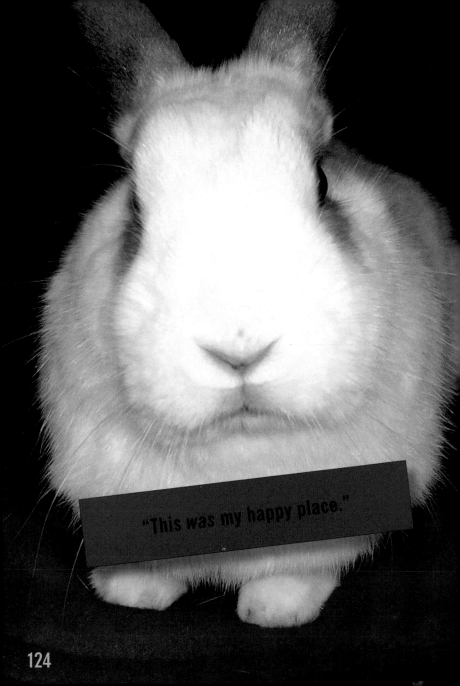

"This was my happy place."

A disapproval so intense it couldn't
be fully captured on film!

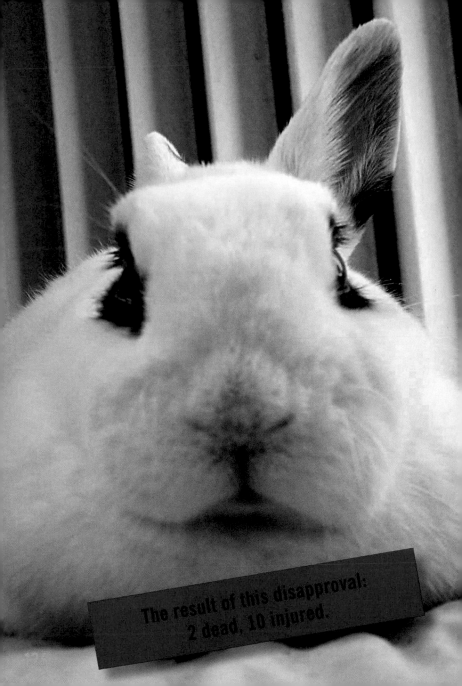

The result of this disapproval:
2 dead, 10 injured.

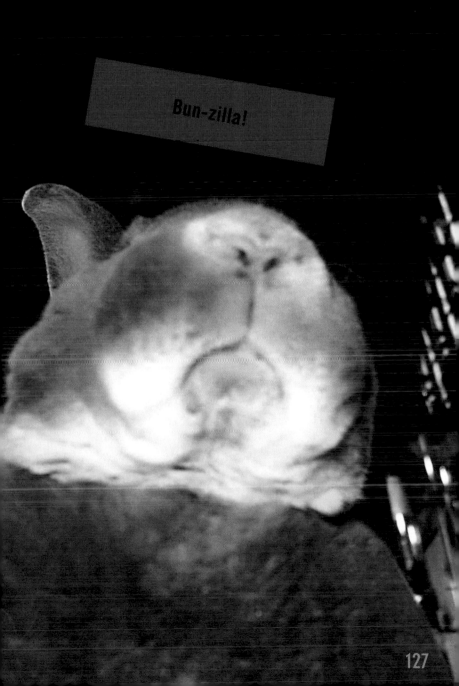

Bun-zilla!

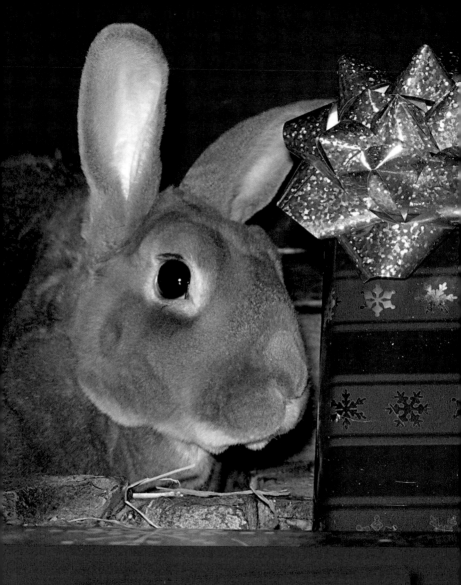

"I disapprove of presents
that aren't for me!"

"That's not how I roll."

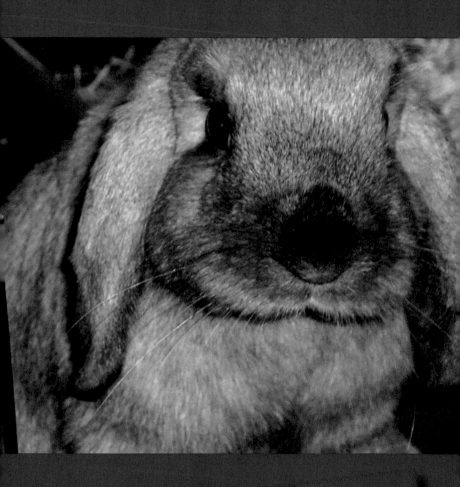

Greta demands you acknowledge her disapproval and stop trying to beep her nose.

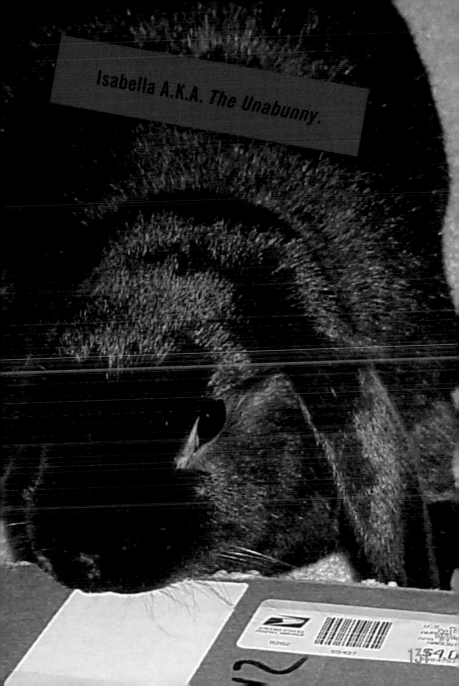

Isabella A.K.A. The Unabunny.

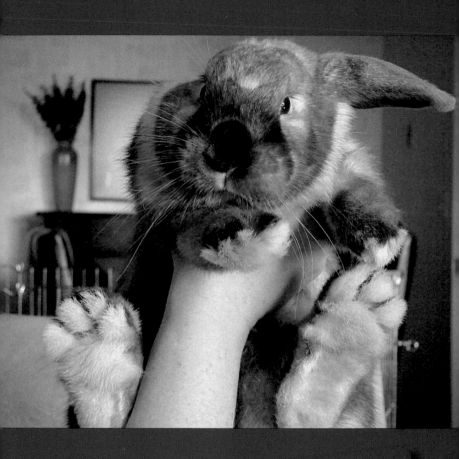

You think this is as intense
as a disapproval gets,
and then you put the bunny down.

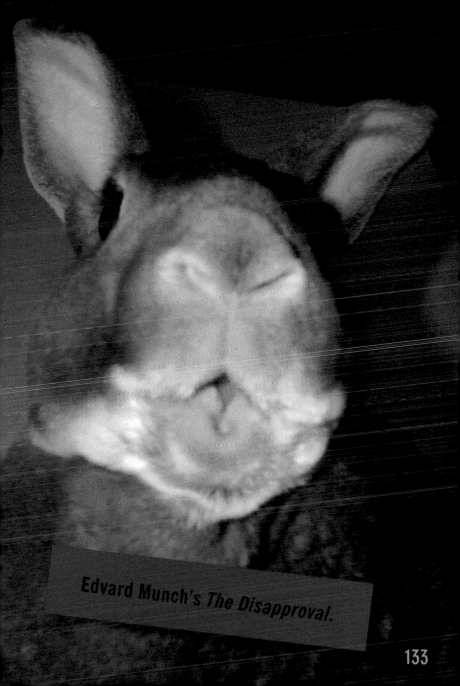

Edvard Munch's *The Disapproval.*

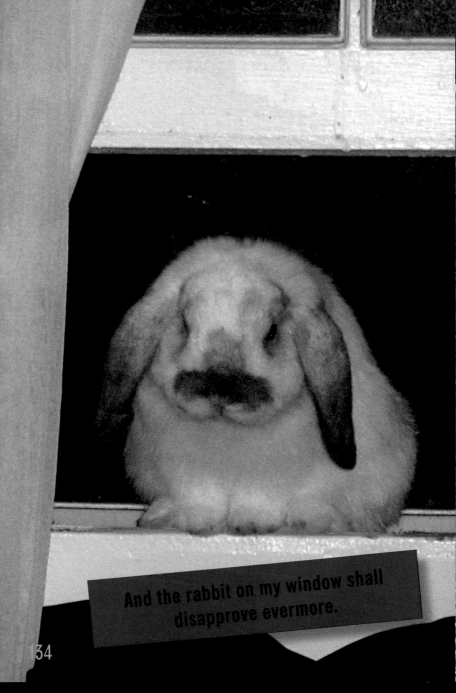

And the rabbit on my window shall
disapprove evermore.

134

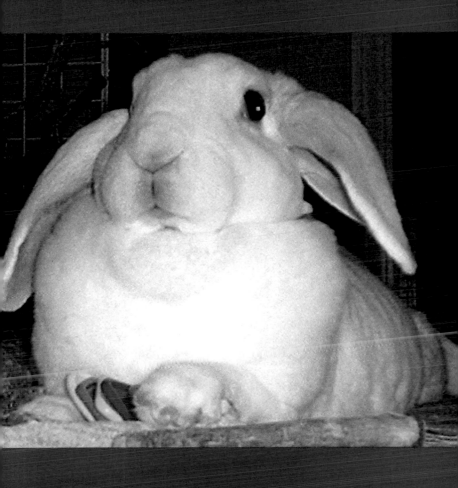

"I'm just going to pretend
you're not here."

135

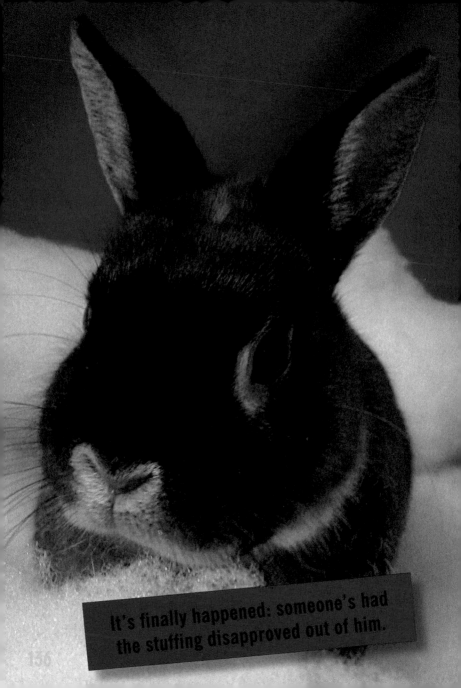

It's finally happened: someone's had the stuffing disapproved out of him.

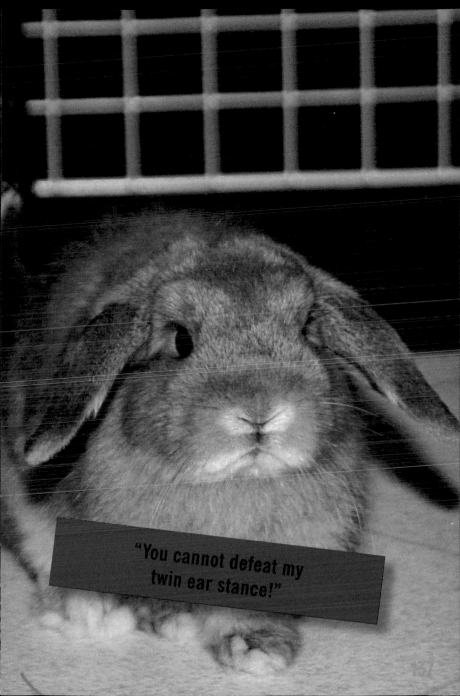

"You cannot defeat my
twin ear stance!"

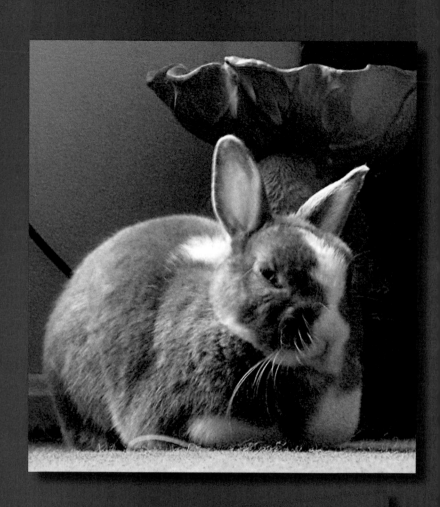

"No, Mr. Bond, I expect you will
fail to meet my standards."

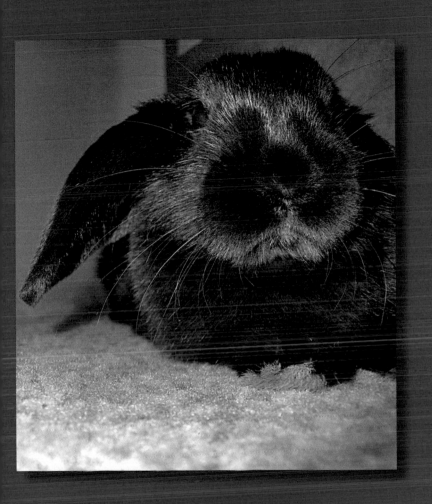

A disapproval so intense that nothing, not even light, can escape.

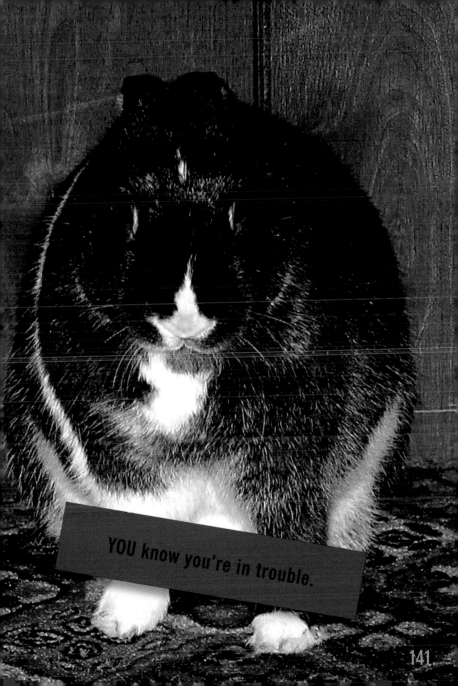

YOU know you're in trouble.

141.

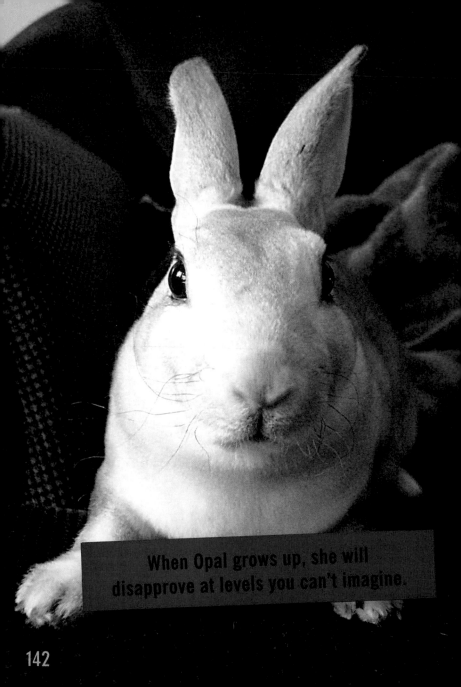

When Opal grows up, she will
disapprove at levels you can't imagine.

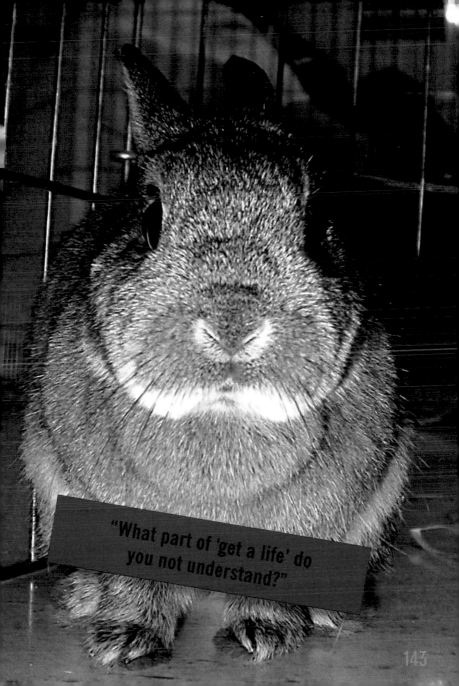

"What part of 'get a life' do you not understand?"

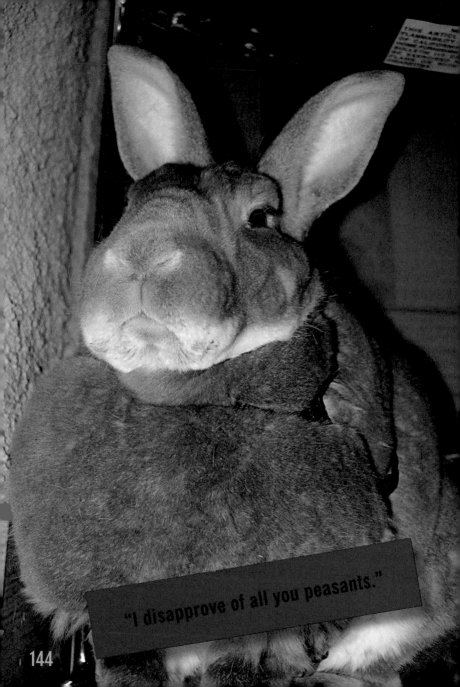

"I disapprove of all you peasants."

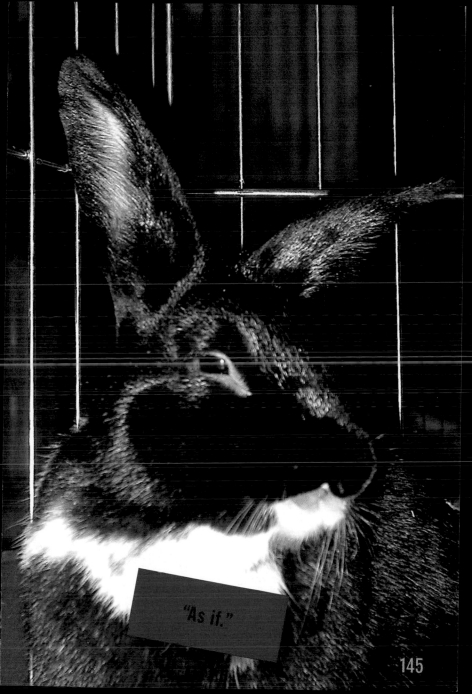

"As if."

145

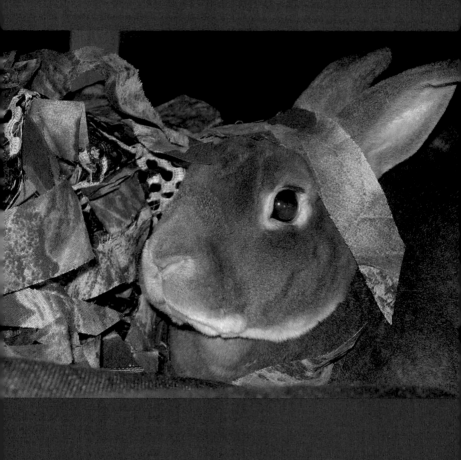

Chapter 8

There Is No Escaping Disapproval

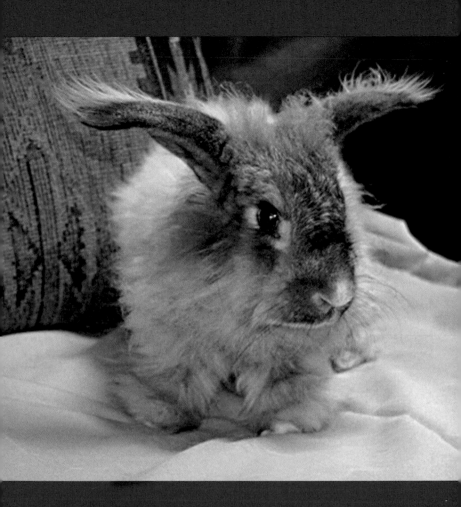

Flaps down, ready for emergency disapproval on Runway Two.

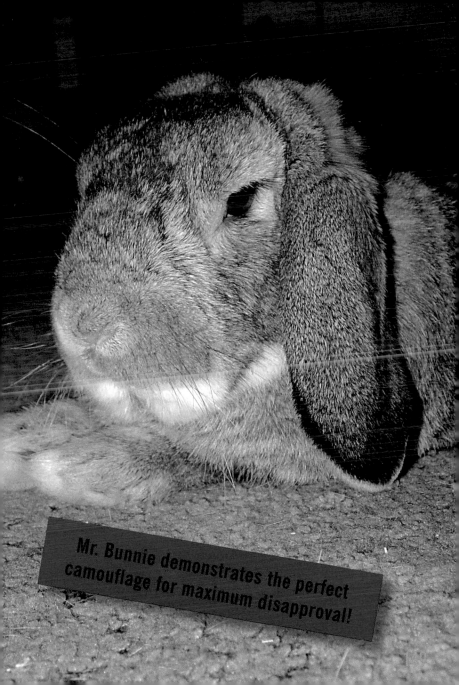

Mr. Bunnie demonstrates the perfect camouflage for maximum disapproval!

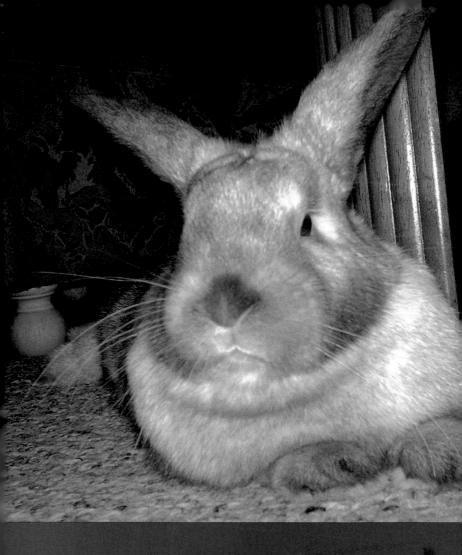

"What, you want a piece of me?"

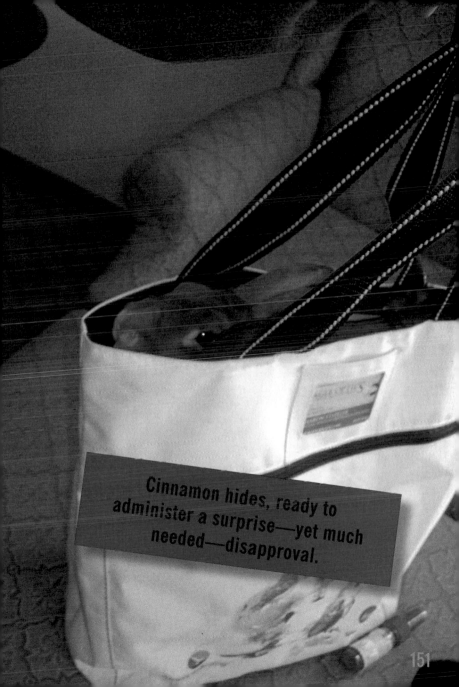

Cinnamon hides, ready to administer a surprise—yet much needed—disapproval.

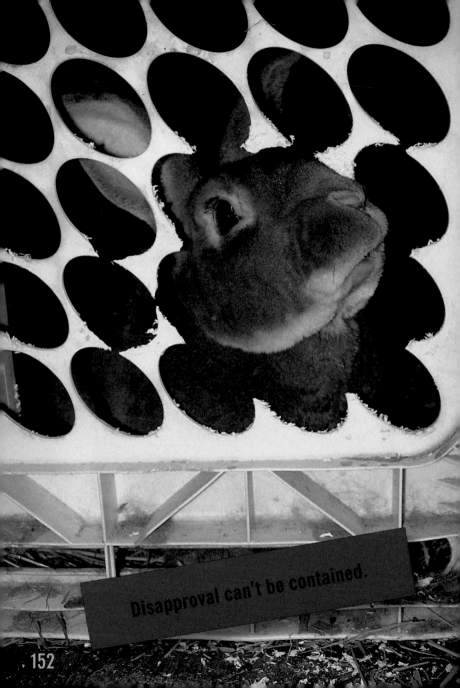

Disapproval can't be contained.

"All you read is trash!"

"It was the strangest thing, dear, but as I was outside I was overcome by the sensation that I was raking the leaves all wrong..."

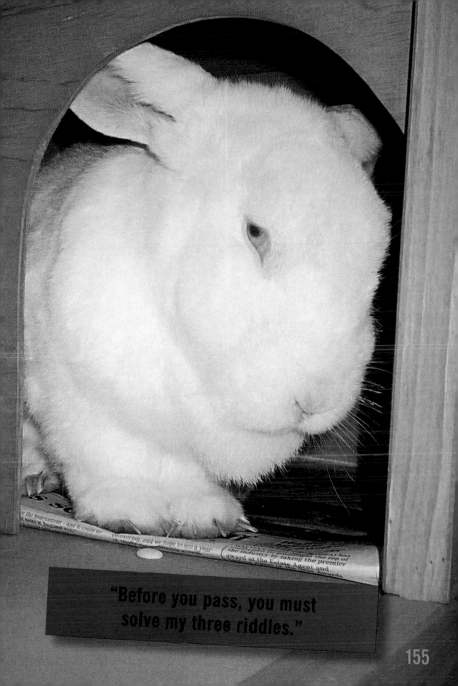

"Before you pass, you must
solve my three riddles."

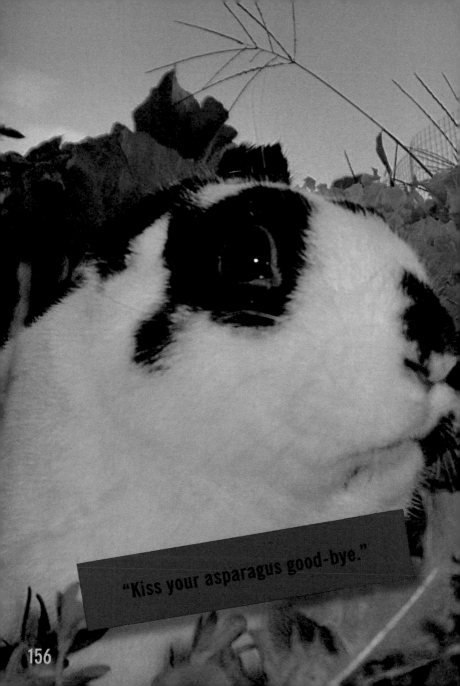

"Kiss your asparagus good-bye."

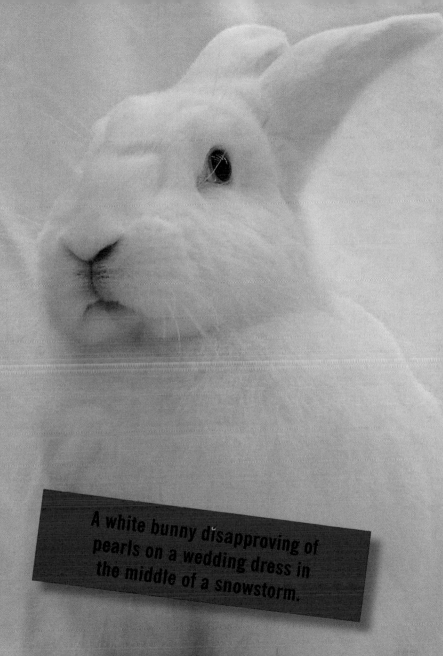

A white bunny disapproving of pearls on a wedding dress in the middle of a snowstorm.

"I disapprove of whatever you're
doing under there!"

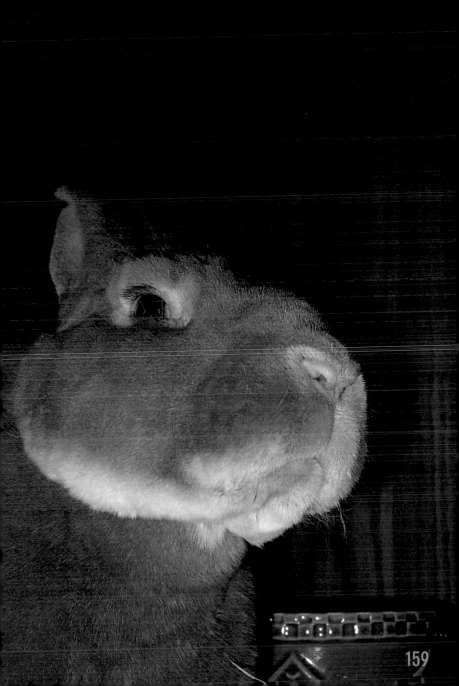

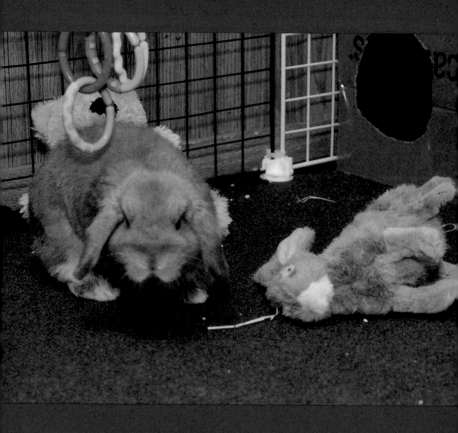

"I disapprove of stool pigeons!"

"I will fade into the carpet and strike when you least expect it!"

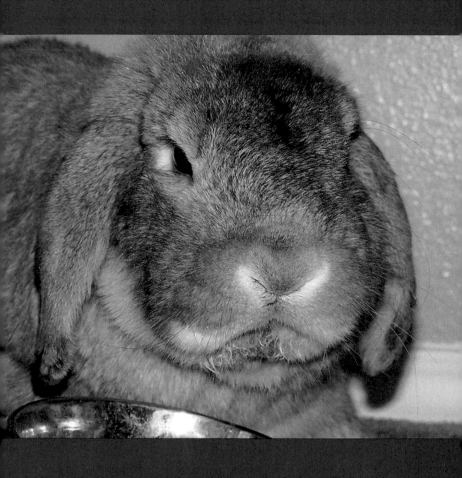

This won't end well.

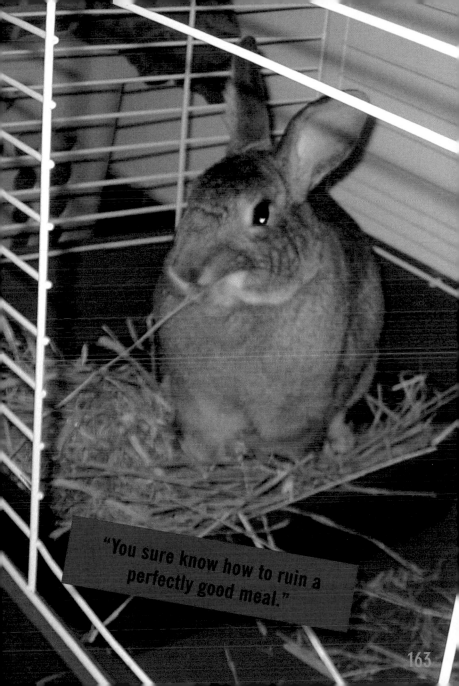

"You sure know how to ruin a perfectly good meal."

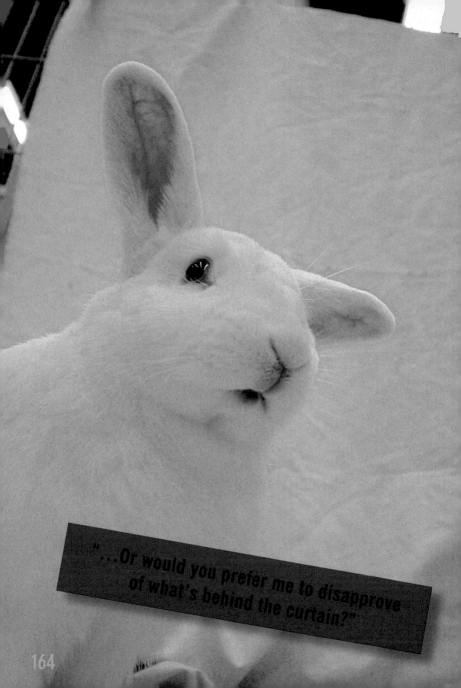

"...Or would you prefer me to disapprove of what's behind the curtain?"

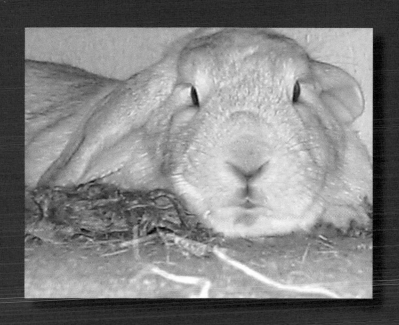

Princess Cricket practices
mellow disapproval.

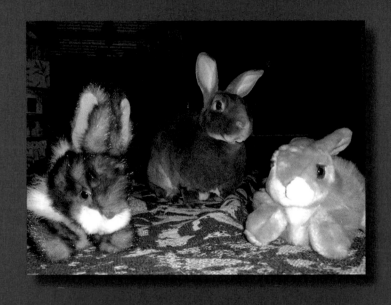

Chapter 9

Loafs of
Disapproval

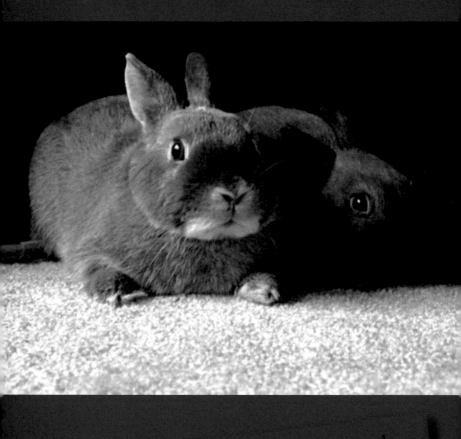

You think these bunnies are scared.
They aren't.
They're shocked. Shocked at how far
below their standards you are.

And when you shift all
your defenses to the left, you notice
a frown coming from the right!

"Over there, 2 o'clock...
something to disapprove of."

"Wait until they go to sleep. Then
we'll exact our revenge."

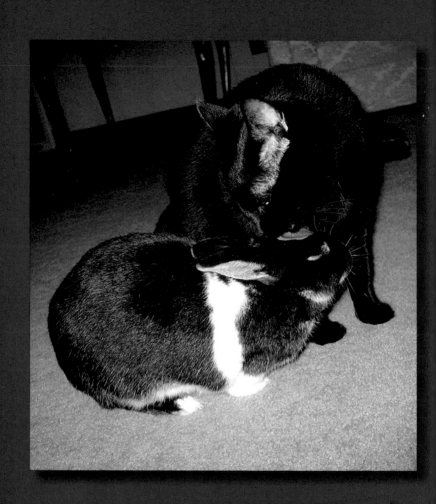

"A sad day when the cat scores
more points than you."

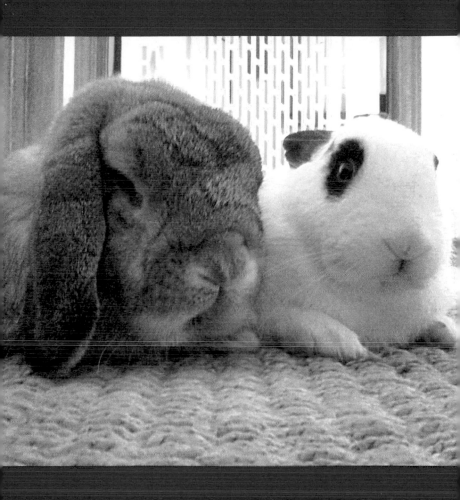

Sometimes a disapproval is so great
a bunny needs back up.

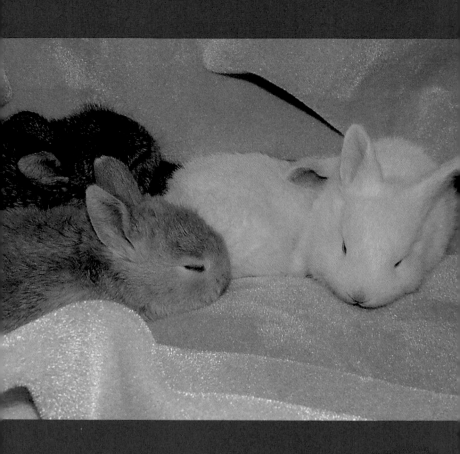

Molecules of Disapprovium: The hardest element in the universe to please.

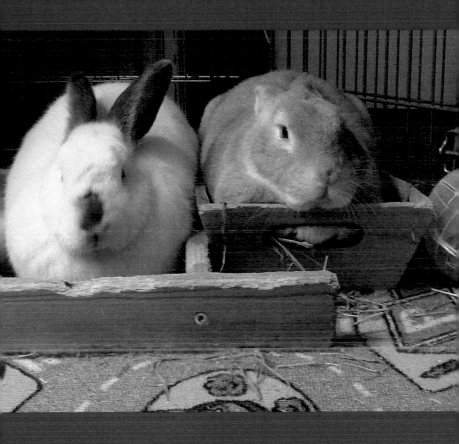

"We the Fashion Police find you...
GUILTY."

175

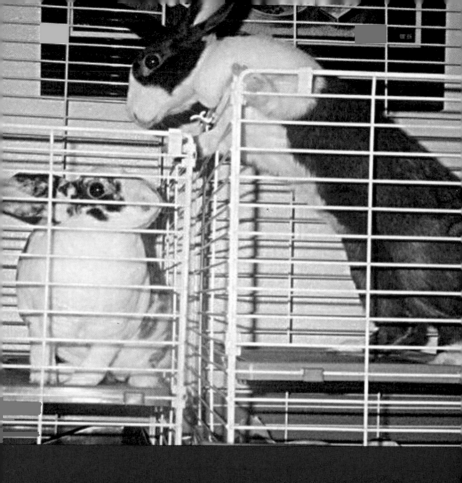

"Psst. Prison break at 7.
Spread the word."

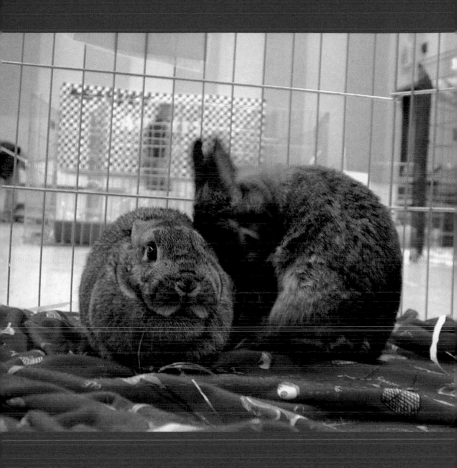

The Yin of disapproval,
the Yang of disinterest.

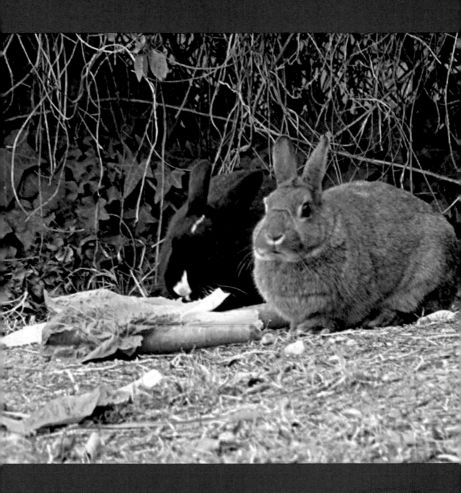

Fresh carrot, fresh air,
fresh disapproval.

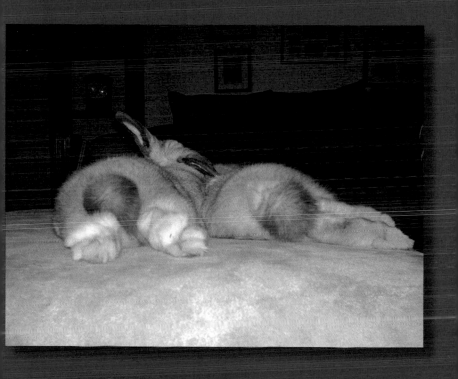

Consider this the happiest
end of a rabbit.

ACKNOWLEDGMENTS

Thank you to my wonderful husband Bill. We would never have had a bunny or even a Web site dedicated to them had it not been for him. Heck, this book wouldn't have been submitted on time had it not been for his help. His help with captions and support were essential to bringing this book to fruition.

SPECIAL THANKS:

Mom, Neil Gaiman, Matthew Benjamin, Merrilee Heifetz, Ari Hoptman, Cinnamon, Latte, Hazel, New Bunny, The Minnesota Companion Rabbit Society. And a special thanks to all of my blog readers. I never really advertised the site, especially the rabbit end (www.disapprovingrabbits.com). You've made life on the Internet very fun and creative.

DISAPPROVING CONTRIBUTORS

Cheryl Darnell, Melinda, Louisa Richards, A Viggiano, Natalie Hooton, Marcy Hall, Delia Guzman, Jill Watson, Hollie Parker, Kelly Tracy, Chris Weigert, Alison Marie Palumbo, Leslie Bulbuk, Carri Ann Cassabaum, Steve Romaine, Els van der veen, Mike Brown, Robyn Wagner, Esq, Jennifer from Binkybunny.com, Margaret Jacot, Stefanie Frank, Michele Hope, Leslie Bulbuk, Mark Evans, Angela Hamilton, Lisa Zorn, Elizabeth Pershing, Patricia Mulcahy, Charlene Pert, L Schoenborn, Susan Spanes, Aimee Proctor, Laura, Wendy Mayo, Sxtysvnchv, Muhkittilitter, Sonia Stephens, Debbie Winsor, Diane Jones, Art Drauglis, Sarah Hopper, Louisa Richards, Jill Reaney, Rebekah Merrifield, Patricia Brainard, Eileen Matias, Colleen Faulkner, Jessi Hustace, Kristin Anne Russo, Kathy Talley-Jones, Allie Adams, Karen, Jill Reaney, Melissa Green, Two Bad Bunnies, Kerrie M. Bushway, Katie Pollock, April Koonce, Erica Loef, Margaret Jacot, Dan West, Sven Bohn, Hoa Ly, Dana Blizzard, Tania Fardella, Shannon Monroe, Marlene Sironi.

ABOUT THE AUTHOR

SHARON STITELER is the Bird Chick, but she is also a lover of all animals great and small. Her site birdchick.com is one of the top rated international birding sites and DisapprovingRabbits.com is featured on many host sites including CuteOverload.com, Collegehumor.com, and FHM.com. She has a weekly public radio show in Minneapolis and appears around the country speaking about birds and conservation. She and her husband Bill live with Cinnamon in Minneapolis, MN. Cinnamon disapproves of Minneapolis.